Painting Class:

Oil

Translated from the Spanish by
MICHAEL BRUNELLE

Project and Publication by
PARRAMÓN EDICIONES, S.A.

Text
DAVID SANMIGUEL

Drawings and Exercises
HÉCTOR FERNÁNDEZ
JOAN GISPERT
GEMMA GUASCH
ALBERTO GUTIÉRREZ
YVAN MAS
ESTER OLIVÉ
ÁLEX PASCUAL
ÓSCAR SANCHÍS
DAVID SANMIGUEL

Photography
NOS & SOTO

Series Design
JOSEP GUASCH

Makeup and Composition
ESTUDI GUASCH, S.L.

Library of Congress Cataloging-in-Publication Data Available

10 9 8 7 6 5 4 3 2 1

Published in 2008 by Sterling Publishing Co., Inc.
387 Park Avenue South, New York, NY 10016
Copyright © 2007 by Parramón Ediciones, S.A., Ronda de Sant Pere,
5, 4th Floor, 08010 Barcelona, Spain.
A company of Grupo Editorial Norma de América Latina
www.parramon.com
Originally published in Spain under the title *Pintura al Óleo*.
English translation copyright © 2008 by Sterling Publishing Co. Inc.

Distributed in Canada by Sterling Publishing
c/o Canadian Manda Group, 165 Dufferin Street
Toronto, Ontario, Canada M6K 3H6
Distributed in the United Kingdom by GMC Distribution Services
Castle Place, 166 High Street, Lewes, East Sussex, England BN7 1XU
Distributed in Australia by Capricorn Link (Australia) Pty. Ltd.
P.O. Box 704, Windsor, NSW 2756, Australia

Printed in China
All rights reserved

Sterling ISBN-13: 978-1-4027-4913-1
ISBN-10: 1-4027-4913-9

For information about custom editions, special sales, premium and
corporate purchases, please contact Sterling Special Sales
Department at 800-805-5489 or specialsales@sterlingpub.com.

Painting Class:
Oil

STERLING
New York / London
www.sterlingpublishing.com

Introduction, 6

MATERIALS OF THE OIL PAINTER, 8
Components of the Paints, 10
A Description of Oil Paints, 12
Colors, Paints, and Pigments, 14
Properties of Oil Paints, 16
Making Oil Paints, 18
Commercial Assortments of Paint, 20
The Artist's Colors, 22
Colors and Blends: Yellows, 24
Colors and Blends: Reds, 26
Colors and Blends: Blues, 28
Colors and Blends: Greens, 30
Colors and Blends: Earth Tones, 32
Regarding the Grays, 34
The Palette and the Order of the Colors, 36
Brushes, Supports, and Solvents, 38
Brushes and Painting Knives, 40
Supports: Fabric, 42
Supports and the Consistency of the Paint, 44
Solvents, Mediums, and Dryers, 46
Making a Wax Medium, 48

Con-
tents

THEMES FOR OIL PAINTINGS, 90
The Figure, Portrait, Still Life, and Landscape, 92
A Universal Theme, 94
Figure in an Interior, 96
The Nude: Study of the Human Form, 98
The Realistic Interpretation of Flesh Tones, 100
Still Lifes in Color, 102
Nature and Urban Landscapes, 104
An Urban Theme, 106
Abstract Painting, 108

PAINTING: THE TECHNICAL PROCESS, 50
The Process of Creating a Painting, 52
From the Drawing to Color, 54
Different Dilutions of Color, 56
Heavy Color, 58
From Light to Heavy, 60
Direct Impasto, 62

STEP BY STEP, 110
An Urban Riverscape, 112
Two Riders on Horseback, 116
A Vase with Tulips, 120
A Landscape Near the Sea, 124
A Still Life with a Limited Color Range, 128
Working with a Painting Knife: Three Pomegranates, 132
Line and Color in the Human Figure, 136
Interpretations of a Still Life: A Colorist Approach, 140
Interpretations of a Still Life: Chiaroscuro, 146
An Urban Landscape, 152

Index, 158

LIGHT AND COLOR, 64
Modeling and Blending Colors, 66
Modeling the Volumes, 68
From Dark to Light, 70
Modeling and Impasto with Local Color, 72
Blending, Value, and Space, 74
Modeling without Blending the Brushstrokes, 76
Light, Color, and Subject Matter, 78
Light from Color, 80
The Brushstroke as Drawing and Color, 82
Color Harmony: Warm Colors, 84
Color Harmony: Cool Colors, 86
Color Harmony: Neutral Colors, 88

Oil Painting,
a Medium Charged with Life

Talking about oil painting is almost like talking about all of Western painting; at least about the majority of the paintings from the distant past that are still in existence. Out of ten great painters that might come to mind, at least eight of them will surely be painters of oils. Certainly, there have been many processes that artists of different eras have practiced and cultivated, but since the Renaissance none have made as much of an impression as oil painting. Today, despite the success of other contemporary media such as acrylic paints, oil continues to be a favorite of professionals and amateurs.

Oil painting is not only a first-rate medium but also one that gives reign to the ingenuity and artistic imagination of the artist. The versatile and sensual nature of oils becomes, in the hands of a true artist, a medium charged with life, intensified by the ability to convert the simplest subjects into truly expressive images that are full of meaning in small universes of sensual and tactile forms. And all this comes from skillful use of the basic techniques.

This book is about those fundamentals and much more. From rudimentary brushstrokes and impasto depicting very simple subjects to the most sophisticated chiaroscuro effects, this book shows, in a very accessible way, everything the reader needs to know about manipulating the richly colored paint that covers the artist's palette. The profusion of examples and diverse styles are accompanied by detailed step-by-step explanations about each technique and manner of proceeding. A book, finally, that will reveal to the unfamiliar reader the attraction of this medium and yet inspire the experienced artist with new possibilities.

Despite its reputation as a difficult technique, oil painting need only be as complicated to master as the artistic ambitions of the painter. It is highly adaptable to each artist's intentions and personal approach.

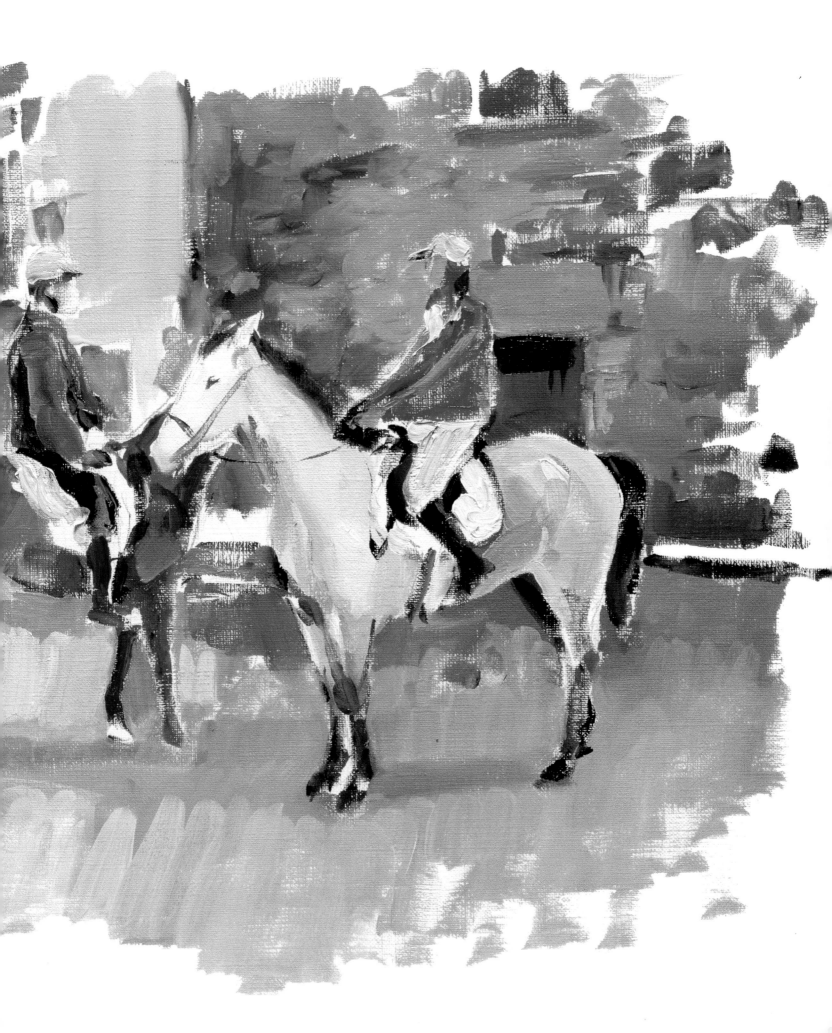

Materials
of the Oil Painter

Components
of the

Paints.

When people talk about oil paints, the first image that comes to mind for many

is a thick colored paste, creamy and bright, that covers everything and takes a long time to dry. All these attributes are owed to a single factor: oil. Oil paints are pigments suspended in oil, which gives them the richness and smoothness that is lacking in many other painting media. What matters most is the quality of the pigments and the condition of the oil. This chapter examines the essence of oil paint—its properties, attributes, and intrinsic nature—and what can be expected of this painting medium.

A Description of
Oil Paints

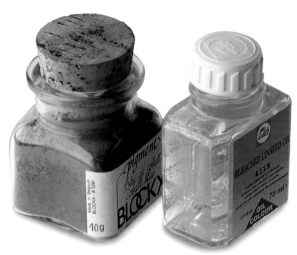

Oil paint is composed primarily of pigments suspended in a drying oil—in other words, an oil that is applied in a thin layer, absorbs oxygen from the atmosphere, and is polymerized (dries) to form a durable and elastic film. Historically, many oils have been used for making paint, among them linseed, walnut, and sesame seed oils. Today, the vast majority of manufacturers use linseed oil for its intrinsic characteristics and because it is easy to obtain. However, a wide variety of oils are used to produce specific characteristics such as drying time, gloss, and color clarity. For example, walnut and poppy seed oils are paler and produce more vibrant whites. Although many artists contend that the best and fastest drying linseed oil comes from cold-pressed flax seeds, most manufacturers use hot-pressed oil because it contains fewer impurities and is easier to obtain.

The only components of oil paint are pigment and oil. The classification (professional quality or student grade) of the final product is dependent upon the quality of both ingredients. The pigments must be ground correctly (each differently according to the color), and the oil must possess the precise amount of drying power and a minimal yellowing factor.

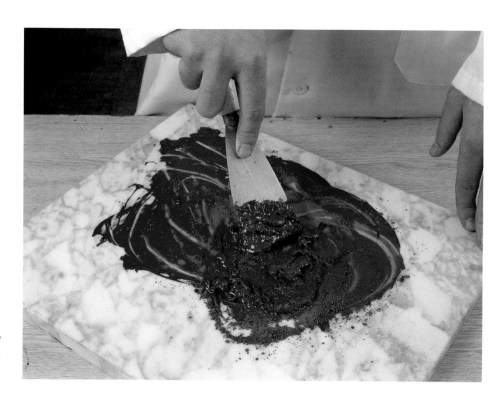

Oil paint is a suspension of pigment in oil (which can be a linseed, nut, or sesame seed oil, among others).

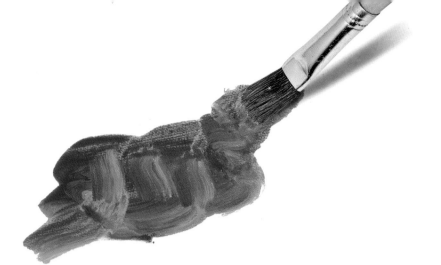

The creaminess and slow drying time of oil paints enhances the mixing and blending of colors and extends the ability to work over prolonged periods of time.

THE PROPERTIES OF LINSEED OIL

The golden tone of linseed oil darkens in conditions where light is lacking and lightens again when it is exposed to light. This is true of both liquid and dry oil, so a painting kept in the dark for a long time will inevitably darken. Some painters who make their own paint leave the oil exposed to light and air for some time so it will thicken and lighten in color and thus minimize the risks of yellowing (visible in the light blue tones in a painting). Boiling the linseed oil will increase its drying properties. Oils of this type are available on the market, but they should be used with great caution because they make the paint layer brittle and they darken greatly over time. Manufacturers normally use different oils for different colors. Generally, the faster-drying paints tend to yellow more; the oils that tend to yellow very little are used to make light colors, and they dry more slowly than the darker colors.

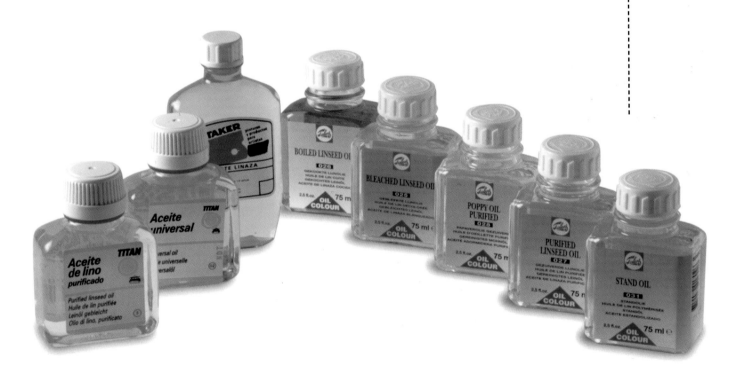

Here is a selection of different artist's oils. From left to right: clarified linseed oil (very light and fast drying, but with a tendency to yellow); universal oil (with a neutral tone, it yellows very little but it is slow to dry); common linseed oil (hot pressed, it is quite yellow and only good for binding dark colors); boiled linseed oil (dark and very quick drying, this type of oil tends to yellow visibly in light colors); bleached linseed oil (specially treated so it will be very transparent and yellow very little, it is used to make light colors); purified linseed oil (made for mixing with solvent and increasing the transparency of the color); and standardized linseed oil (another name for universal oil).

Colors, Paints
and Pigments

Pigments are substances with particular chemical compositions that are used for making industrial and artistic paints, including artist's oil paints. Paint can be fabricated using a single pigment or several pigments. Pigments have names such as *chromium oxide cobalt* (used to manufacture certain blue paints), *quinacridone* (for scarlet red), or *phthalo copper chloride* (for some greens), among many others. Colors, properly speaking, are remembered or actual perceptions, experiences that we name in many ways: when we say apple green, we name an experience, a sensation, a general idea, and also a memory that can find a more or less adequate equivalent on our palette. Paint is, ultimately, a compound that we can use to evoke a specific experience of color.

The industry uses a universal code for each pigment, no matter where it originates. Different brands do not always use the same pigments to manufacture paints of the same name; therefore, the only valid reference is that which is on the tube. The pigment used to manufacture the oil paint should be on each tube. In this case we have a quinacridone red.

The major oil paint manufacturers sell a wide range of paint (in the illustration are color charts for Talens, Schmincke, and Winsor & Newton). These color charts are often made with samples of real paint.

Painted samples of a Winsor & Newton color chart. This reference is more accurate than one where the colors are printed on the chart.

OIL PAINT

It is important to be clear on the meanings of "pigment" (base powder), "paint" (paste mixture), and "color" (visual appearance) to avoid confusion when choosing a particular oil paint. The name of the paint (the color) that is printed on the container does not necessarily coincide with the name of the pigment used to make it. Usually, if the word "Hue," in parentheses, follows the name of the pigment, this means that the paint is an imitation of the color of that pigment. That is, the paint is artificially formulated to look like that pigment. It is generally preferable to choose good quality paint that does not carry that labeling.

THE PIGMENT CODE

On the label of a tube of oil paint there is, along with other information, the name of the color (*lemon yellow, scarlet red, manganese blue,* etc.) and also a code that indicates the pigment used in its manufacture. This code consists of two letters and a number. The numbers indicate the particular type of pigment: the letters can be Pw (white pigment), Pr (red pigment), Py (yellow pigment), Po (orange pigment), Pg (green pigment), Pb (blue pigment), Pv (violet pigment), PBr (brown pigment), or PBk (black pigment).

It is very important for the artist to use oil colors that guarantee their manufacture, permanence, and durability. In addition, the paints used should be completely compatible with each other to avoid undesired reactions between their chemical components.

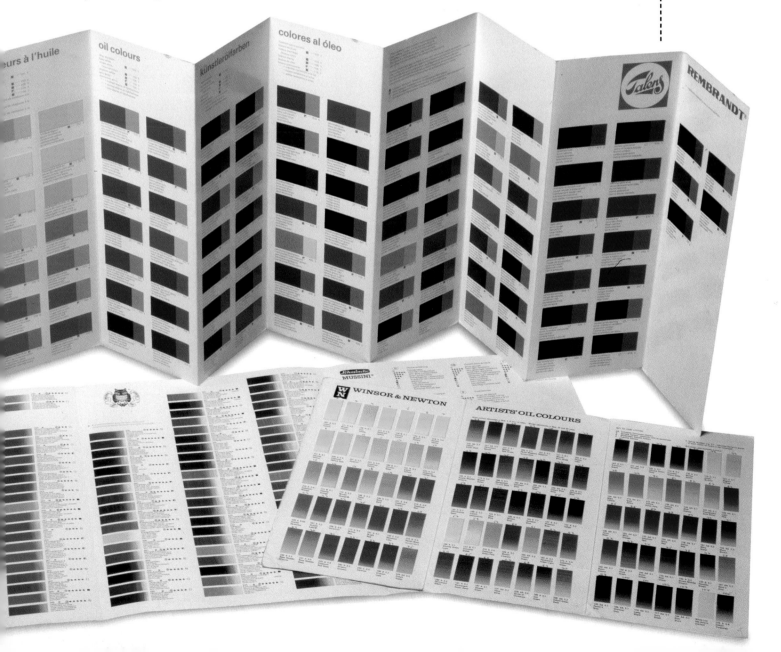

Properties of Oil Paints

The label on a tube of paint tells more than just the pigment or pigments used to manufacture it. It also lists the base suspension, or vehicle, used, which is usually linseed oil or, for lighter colors, sesame seed oil. Additionally, the label specifies the paint's lightfastness, or permanence, and indicates its level of transparency, described as transparent, semitransparent, or opaque.

LIGHTFASTNESS AND TRANSPARENCY

One of the jobs of the vehicle (the oil) is to provide maximum protection to the pigment against fading. A color's lightfastness is specified by a number; however, various testing methods use differing scales and designations. For example, the ASTM scale rates permanence as I through V, with I being the best, while the "blue wool" scale ranges from 1 to 8, with 8 being the best.

More important is information about the paint's transparency or opacity. The density and creaminess of oil paints would make you think that they are very opaque, but this is not necessarily so. *Carmine* (red) and *turquoise* are very transparent, and there are few oil paints that are completely opaque. The transparency of a paint depends entirely on the amount of pigment used and can vary from total opacity through varying degrees of transparency. In mixing paints, opaque paints always dominate transparent ones. Since the majority of white paints are very opaque, the quickest way to make a transparent paint opaque (while altering the tone as little as possible) is to mix it with a little white.

Another factor to consider is the drying speed, which varies greatly from one paint to another. Paints made with earth elements (for example, pigments of iron oxide) dry fairly quickly, while others, for example, titanium white and ivory black, dry quite slowly. The logistics of drying times dictate that paints requiring longer drying times be used in the earlier stages of work.

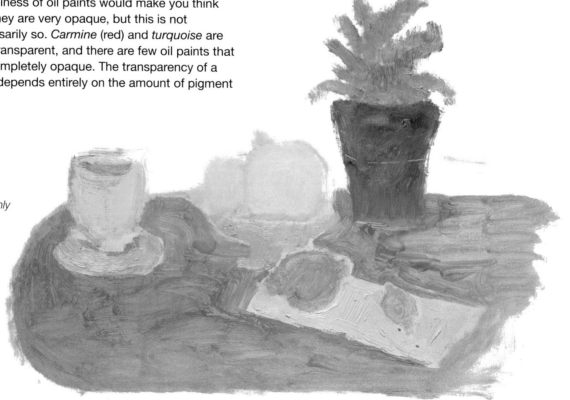

The transparency of oil paint mainly depends on the pigment. These oranges (quinacridone) are transparent and the brushstrokes are visible. However, when the transparent color is mixed with white, a completely opaque color is created, as can be seen in the details of the areas of impasto.

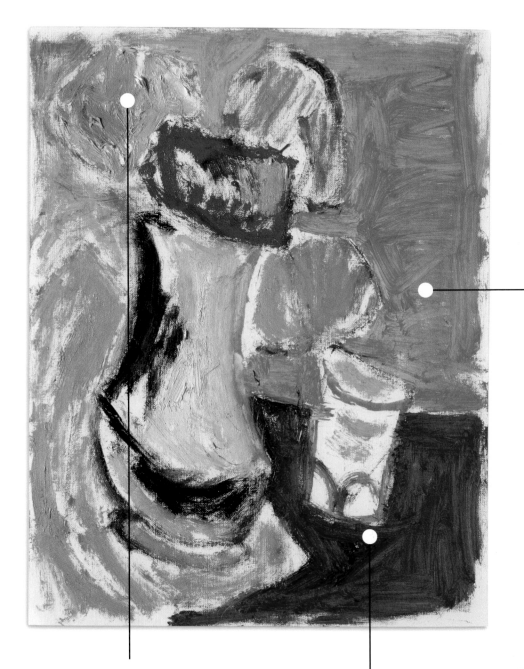

Carmine is one of the most transparent oil colors, even when it is applied in very thick layers or on very textured backgrounds.

The yellows and oranges are usually transparent, except for those based on cadmium pigment.

This pink is a mixture of crimson and white. The white completely neutralizes the crimson's transparency.

Nearly all the colors based on the pigments known as the earth colors are transparent. This color is burnt sienna.

Sometimes artists manufacture their own oil paints to get just the right consistency for their needs. This is not difficult to do if you have the time and patience. The most obvious advantage is the money saved, and with a little perseverance, results that rival the quality of commercial paints can be achieved. All that is needed are powdered pigments, a special pestle (made of glass with a wide flat base), and a perfectly smooth surface, for example, a marble slab or a sheet of glass.

Making Oil Paints

MANUFACTURING PROCESS

A small pile of pigment is deposited in the center of the working surface. A well is then made in the center of this pile, and oil is poured into it. A very small amount of oil is used because its ability to bind pigment is much greater than it would seem at first glance. Next, the pestle is applied to the oil and pigment, and they are mixed together by making continuous rotational movements. This is continued until the paint has an even consistency. If the consistency is too fluid, more pigment may be added during the process. Finally, the paint is scraped up with a palette knife and placed into metal tubes that can be bought at art supply stores. Ideally the paint should be left to rest for a few weeks to allow excess oil to make its way to the surface and then be eliminated by "decanting" the paint. Manufacturers of quality paint sometimes allow it to rest for several months.

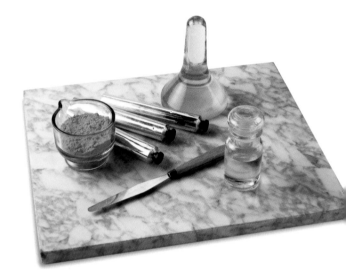

1

1. The oil is worked on a marble slab, or a ceramic or glass surface. A wide glass pestle is required, along with pigment, linseed oil, a palette knife, and refillable metal tubes.

2

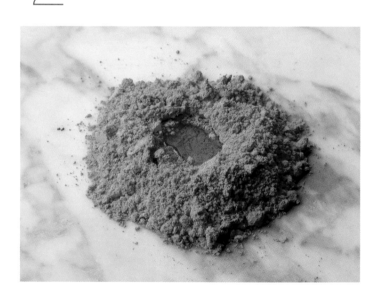

2. A small amount of linseed oil is deposited in a depression made in a small pile of pigment.

PRESERVATION

No special care is required for preserving the paints. The only preventative measure is tightly closing the lids after each session. When a tube has some dried paint in the top, it can be opened up with a tooth pick to allow the good paint to come out. When this is not possible because of the hardness of the dried paint, a last resort is to open the tube at the bottom to extract what is left of the useable color.

When the paint has hardened in the threads and keeps the cap from being removed, the best solution is to heat the threads with a flame; the tube can then be easily opened.

3. The mixture is ground using continuous circular motions to eliminate all lumps.

4. If the paint is too fluid more pigment may be added during the process. The result should be a paste with a dense consistency and no lumps.

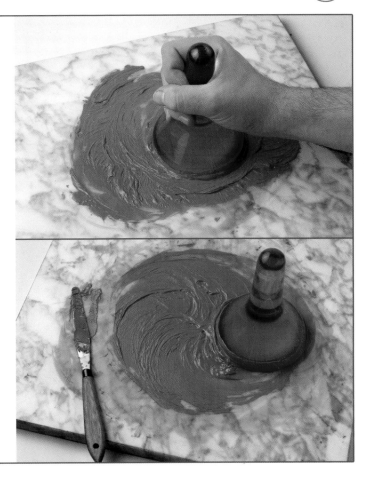

5. The paint is inserted into the bottom of the tube, and pushed down to the other end.

6. Finally, the tube is closed while making sure that not much air is left inside.

Commercial Assortments
of Paint

Large jars or tins of paint are used for very large projects. They are more economical but have an inconveniently large amount of exposed surface that causes it to dry quickly.

Oil colors come in metal or plastic tubes with screw-on tops, in various sizes, and basically in two qualities, student and professional. Two of the more common sizes are 1.25 oz (37 ml) and 5 oz (150 ml) tubes. Normally you would select a medium size for all your colors, except for white, which should be a larger tube. There are also tins containing over two pounds (one kilogram), used by artists that like to paint thick impasto, and cans of liquid oil for decorative work.

STICKS

The most recent development in the variety of oil paints is the paint stick, which is similar to pastels but larger in size. When the stick is rubbed across the canvas, the material becomes slightly fluid, making it very easy to be used in works that require a cursive, sketchy treatment. The lines made by the sticks can be worked with brushes and diluted with solvent just like conventional oil paint.

Paint sticks are an interesting alternative for artists who like lines and very spontaneous painting. They are sold in different diameters.

BOXES

The artist's oil paint box is an important part of his or her normal equipment. The boxes are sold empty or with an assortment of colors, brushes, and solvents, as well as a palette. The sizes and quality vary, ranging from a student box to the luxuriously large studio box made of hardwood. The boxes allow you to transport materials and consequently are not required by painters who work solely in the studio. As for the assortments of colors included in the boxes, the characteristics of oil paint allows all sorts of mixtures, no matter how complicated, and unique colors can be mixed from a half dozen basic colors. Strictly speaking, the primary colors (blue, yellow, red) and white are enough to create all the other colors. But no painter limits his or her palette that much. All artists have their preferences and those colors that they know they are going to use, be it those that are essential for mixing or those special tones that they do not wish to spend time patiently mixing. It is best, therefore, to make a personal assortment of colors based on what you wish to do.

Oil colors are sold in tubes of different sizes, according to the brand. Each company sells large tubes of the most used colors. It is a good idea to have a large tube of white, which is used quite a bit more than the other colors.

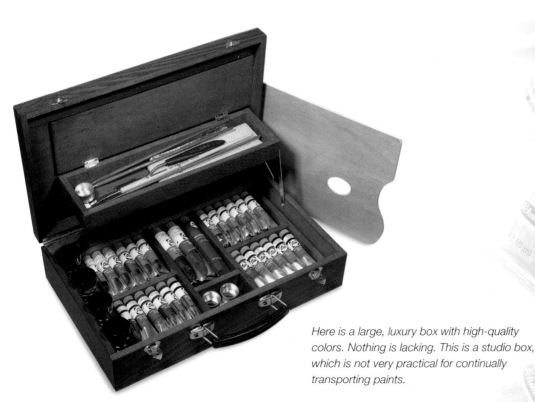

Here is a large, luxury box with high-quality colors. Nothing is lacking. This is a studio box, which is not very practical for continually transporting paints.

The Artist's

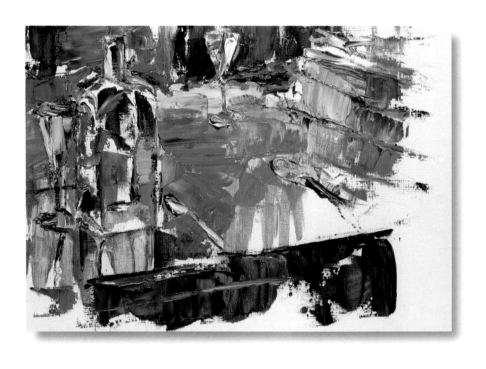

Colors.

In theory,

all colors can be mixed

using three primary colors. However, no painter creates his or her colors by mixing just these three, but rather incorporates into his or her palette all the tones that will most easily allow the desired colors to be mixed. These tones can be used straight from the tube as well as for mixing. One green is not interchangeable with another green, since the first can give good results in light, vibrant color mixtures, while the second is better for creating deeper tones. Personal taste determines the choice of colors when composing a palette, and it is best to be aware of all the options. In this chapter we present the large chromatic families and their most outstanding components.

Colors and Blends:
Yellows

These are the most luminous, warm, and vibrant colors on the artist's palette. Yellow paints are manufactured from approximately a dozen different pigments, which, by combining in various proportions, gives way to a considerable range of colors. One or two of the oils shown here could be added to the palette. Any one of them has all the exhibited characteristics of high-quality paint. In the event of choosing just one, for practical reasons, we recommend a hansa or azo lemon yellow.

ORANGE PAINTS

Although orange is a color that is easy to make with simple mixtures, it is worth including an orange color on the palette to offer a direct route to that extremely warm and saturated tone.

The most commonly used orange is cadmium orange pigment (PO 20), solid and opaque as are all cadmiums, and also quite dominant in mixtures. Another more delicate alternative is pyrrole orange (PO 73); with a reddish tendency, it is usually mixed with yellow pigments of the azo type and sold under the name *transparent orange*.

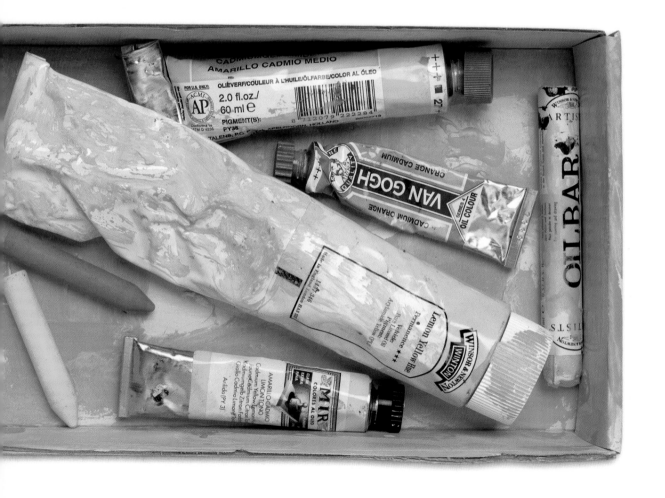

The yellows are the most luminous colors on the painter's palette. Many artists are content with one of them, lemon yellow. But it is always interesting to have a good cadmium yellow and another more delicate one, such as hansa yellow for mixing pale greens.

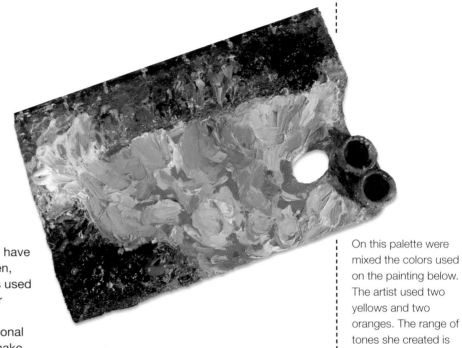

MIXTURES WITH YELLOWS

The yellow paints have the most fragile tones. They have very limited variations and quickly tend toward green, orange, or brown. Therefore they are almost always used without mixing. However, they are indispensable for making shades of reds, ochres, and greens, which thanks to yellow can be developed in uniquely personal ways. They hold surprises: Mixed with black they make dark green, and mixed with the darker earth tones they can turn into acid green colors. It is worth experimenting with them.

On this palette were mixed the colors used on the painting below. The artist used two yellows and two oranges. The range of tones she created is spectacular.

From left to right and above to below: hansa yellow, light and transparent with a delicate tone; cadmium lemon yellow and medium cadmium yellow (opaque and solid yellows); dark hansa yellow, a yellow with beautiful tonality and less opaque than the cadmiums; benzimida (azo) yellow (half-way between lemon yellow and red); and cadmium red orange, a very strong and saturated orange.

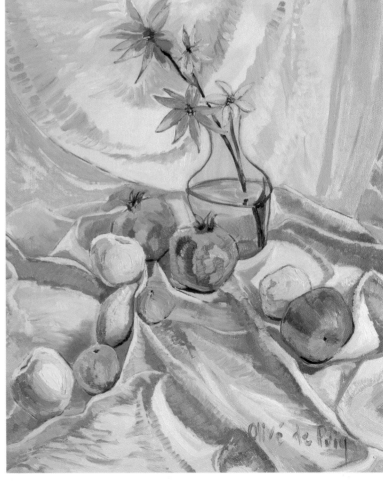

This painting is almost exclusively done in yellows and oranges, thus its extraordinary luminosity. It is an example of a painting done in a very limited range of colors. Work by Esther Olivé de Puig.

Colors and Blends:
Reds

The chromatic strength of the reds cannot be matched by any other color on the palette. Its wide range, extending from orange to violet, makes it necessary to have two or three reds on our palette. As opposed to the translucency chosen for the yellows and oranges, the most popular red is cadmium red. Solid, covering, and opaque, it is the most powerful of all the red paints. It has few drawbacks, except for the possible muddiness of some the mixtures made from it; the pinks tend to be earthy and the violets somewhat lifeless. The naphthal reds and especially the very luminous quinacridone reds are recommended as good substitutes or complements for cadmium red. These two varieties make splendid oranges and excellent pink tones of great liveliness and luminosity.

These are the reds that are most commonly used by painters in oil. From left to right: vermillion, luminous but not very opaque; two reds: cadmium red medium and cadmium dark, which are very saturated, opaque, and have good covering power; alizarin crimson, a very transparent color used by almost all painters; quinacridone crimson, somewhat more earthy than the previous but just as transparent; and quinacridone red light, very useful for mixing luminous oranges and violets.

The reds are the painter's most powerful chromatic choice. From vermillion through the cadmium reds, to crimson, there must be at least two of them on the palette.

CARMINE

This color deserves a separate mention. Carmine, or alizarin crimson is a true classic on the oil painter's palette. It was a basic color before the arrival of paint made of biological pigments. Magnificent violets and excellent oranges can be mixed using crimson. This color has two virtues: its own deep and velvety color, strong and very luminous, and the delicate and luminous pinks that that can be made by mixing it with white.

The saturation and the luminosity of the commercially available reds vary greatly in the pigment used in their manufacture. The red tints also range from red orange to purple, which increases the artist's choices.

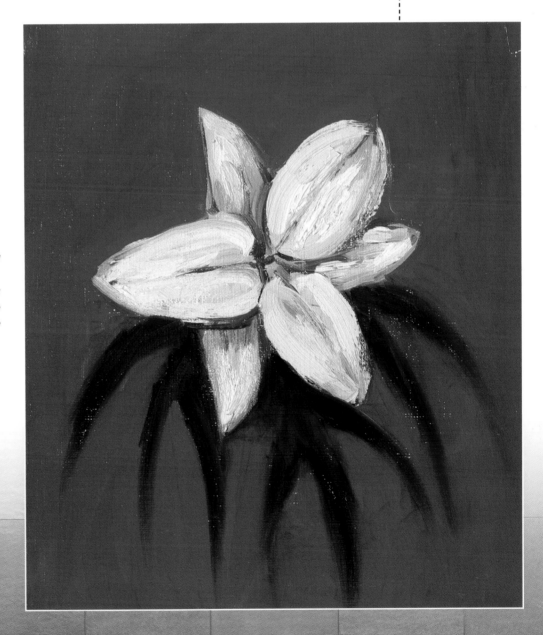

The background of this small work is painted with a dark cadmium red, a very saturated, very opaque color with strong covering power. The pinks of the flower were made with alizarin crimson, which is much more delicate and lightened with white. Work by Yvan Mas.

Colors and Blends:
Blues

These are the blues that painters use the most. From left to right: ultramarine blue, with a reddish tendency and very deep color; cobalt blue, more green than ultramarine, more transparent, and with a very saturated tonality; phthalocyanine blue, greenish, transparent, and very luminous when mixed with white; and Prussian blue, more green and with a very deep tone.

The most commonly used blue is ultramarine, slightly violet and with a deep rich tone. It is an extraordinarily useful color that can be used to mix very luminous and lively blues when lightened with white. Cobalt blue, lighter than ultramarine, is a medium blue (between violet and green), tending toward sky blue when it is mixed with white. Prussian blue has a green tendency, cold and metallic. Used straight from the tube is very deep and beautiful; mixed with white it gives us a wide range of somewhat pasty tones. It tends to muddy mixtures, and its tints vary quite a lot from one brand to another. The phthalocyanine blues are made from organic pigments (synthetics). They are a relatively new addition to the market considering the long history of oils. They are very luminous, transparent, and of excellent quality. Some painters, however, consider these blue colors a little artificial and too "electric."

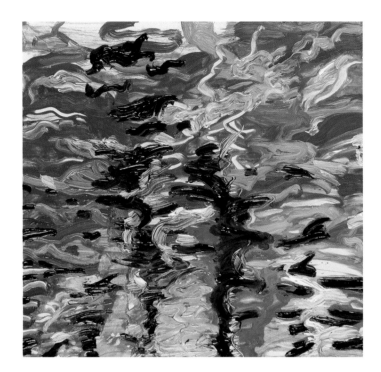

The blues are usually very dark when they come out of the tube. They even can look black if they are applied heavily. This happens especially with Prussian blue and ultramarine. This lack of luminosity disappears when it is painted thinly on the support.

Blue immediately evokes the sky and water. This painting represents the highlights and reflections on water and demonstrates the extraordinary richness and simple harmony that can be created when using blue alone. Work by Gemma Guasch.

THE BLUES, COOL COLORS

Blue is the cool color *par excellence*: the color of the sky and the atmosphere. Psychologically, blues create a sense of receding, distance, and spatial depth. When an artist wishes to "cool off" a color, he or she will use some blue in the mixture. This nearly always means creating a gray, which can be warmer or cooler according to the amount of blue that is included. But not all blues are equally cool; each one has its own chromatic tendency toward either green or red. The one closest to red is, of course, violet. Among the blues, ultramarine is the one with the greatest tendency toward red, followed by cobalt blue, halfway between red and green. The phthalo blues have a somewhat green tendency, and Prussian blue decidedly tends toward green.

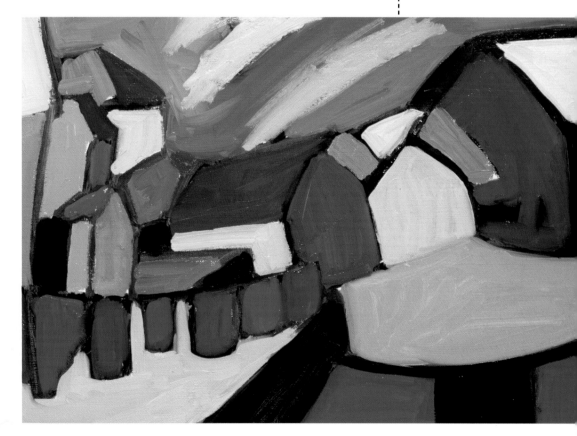

This painting uses the four blues, ultramarine, Prussian, cobalt, and phthalo, and shows how they react to each other. Each of them has a different amount of "coolness," phthalo being the coolest of all and cobalt the warmest. This painting was inspired by a landscape by Gabriele Münter (1877-1961) and is the work of Yvan Mas.

Colors and Blends:
Greens

The green pigments used in the manufacture of oil paints are few (barely ten), but combined with yellow and blue pigments they generate a large number of different colors. Nowadays, the painter can limit himself to the exclusive use of phthalocyanine greens, which have clean, luminous, and vibrant tones, and not require any other green. However, it is worthwhile to try traditional greens like Hooker's (a combination of pigments that make a very natural and "juicy" green), cobalt green, and chromium oxide green (very opaque and slightly velvety).

These are the four most popular greens in oil painting. From left to right: cobalt green, very transparent and natural looking with a warm tendency; permanent green (composed of various pigments), which gives a medium green, saturated with good covering ability; emerald green, transparent and with a bluish tendency, will render some very bright greens when mixed with white; and viridian green, transparent, dark, with a warm tendency, this gives great results mixed with yellow and even the earth colors.

Because of their characteristics, the greens perfectly adapt to colorist and valorist painting. They work better for chiaroscuro painting than most colors (they can be darkened without losing their color), and some of their colors stand up to the brightest colors on the palette in brilliance and intensity.

FROM YELLOW TO BLUE

These two colors (yellow and blue) are the limits of green's territory. It is a very large and varied territory that is characterized by extensive tonal variations. This means that we can use a large number of different greens, from the lightest to the deepest, without the need to use white in the mixtures. In other words, without reducing its chromatic power. Painters rarely use green directly from the tube, but adjust them with yellows and blues based on whether they want lighter or darker tones. But the greens are not only successfully mixed with yellows and blues; small amounts of red can be used to create olives and earthy greens. Burnt sienna is also a good conplement in the mixes: added to a luminous medium green it produces a very interesting warm tone like a shaded gray.

The large number of different greens made from the various pigments and their combinations makes this group the one with the most colors. Blue and yellow are partners when mixing new shades.

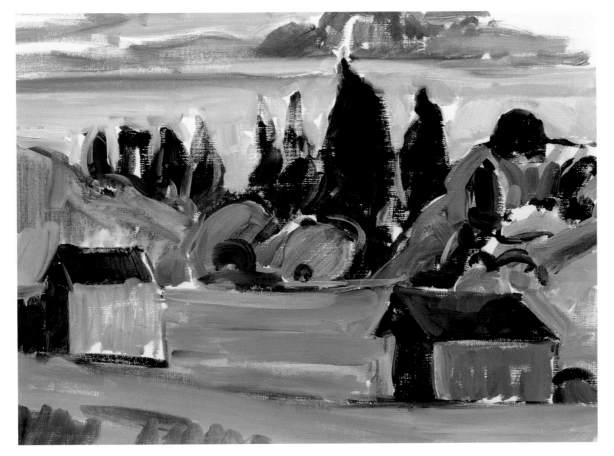

Cool, light, and dark greens, all these are just as they come from the manufacturer, perhaps with the exception of olive green, which has a neutral tendency. It is interesting to observe that sometimes when using green in a woodsy landscape, the result is a cooler feeling than in nature. This is due to the characteristics of the pigments, which have purer and cooler tones than the greens in nature.
Work by Óscar Sanchís.

Colors and Blends:
Earth Tones

From left to right and above to below: burnt sienna, a transparent and exquisite reddish brown; raw sienna, also transparent and much lighter, not much covering power with a golden ochre tendency; yellow ochre, an opaque earthy yellow that covers well; raw umber, very dark and with a greenish tendency; burnt umber, very dark, very transparent, with a tendency toward red; and red oxide (also called English red), very opaque and covering, with a dark roof tile tone that dominates in mixtures.

The earth tones are the easiest pigments to obtain and also the oldest. Traditionally, they were manufactured from natural powders (mainly coming from Italian mines) rich in iron oxide, and for this reason they are mainly reds, oranges, and yellows. Nowadays, they are synthesized in large chemical plants. These are solid and very stable colors that cannot be missing from the painter's palette. Raw sienna is a yellow-brown pigment that, when burnt, turns into a clean and transparent brown: the irreplaceable burnt sienna. Another common pigment is raw umber, a greenish shade that can also be burnt to produce a more reddish and transparent color. The ochre earth colors range from orange to bright yellow, while the red earths like red oxide have a dark, almost maroon color that is very opaque. Today many of these colors are sold under names like *mars yellow, mars red,* and *mars violet.*

The earth tones are colors that include a large number of different pigments of natural origin. They possess an incomparable warmth and are of great use for harmonizing well-balanced paintings.

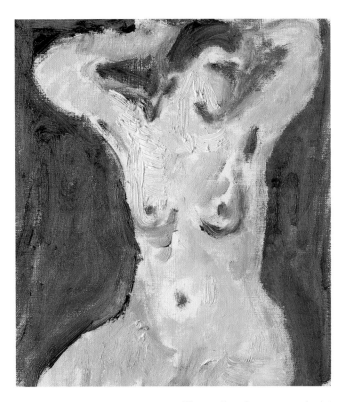

A BEAUTIFUL AND ECONOMICAL CHOICE

Because they are so easy to acquire, paints made with pigments based on iron oxide (the earth tones) are the least expensive on the market. This has nothing to do with their quality, which is usually very good in almost all brands. The warmth and richness of their colors, as well as their fast drying time, makes them very useful as the base colors of a composition and for shading the drawing of it. Many of these colors are transparent, which adds further possibilities for their use: Applying thin layers of burnt sienna, for example, over completely dried pale or white bases will create areas of rich transparencies that add sensuality and warmth to the modeling of the subjects.

The earth colors are used a lot for making different grayish tones and for creating deep and warm dark colors. Because they have less chromatic strength, they are very useful as supporting colors for saturated reds, yellows, and greens. The color harmonies based on earth tones are particularly sweet and warm. Work by David Sanmiguel.

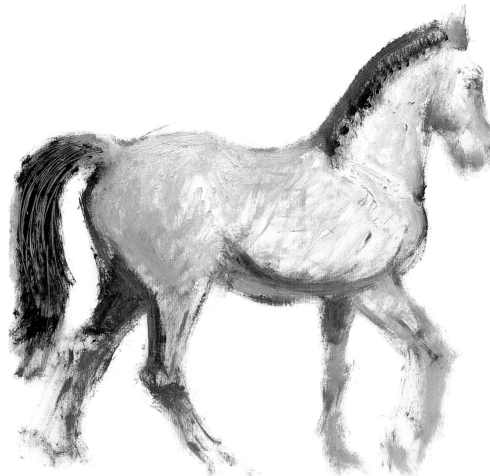

This work is a grisaille in burnt sienna. The painting is interesting because of the monochromatic treatment of the subject. Work by David Sanmiguel.

Regarding
the Grays

For the artist the grays are colors in themselves, and they make up the most extensive chromatic family imaginable. Most of them appear on the palette without trying; they result from accumulated mixtures of various colors. For the beginner, these grays can present a problem, since they muddy the colors and reduce the chromatic quality of the work of art. However, when they are purposely mixed, the grays reveal themselves to be the widest of all possible color ranges. Warm and cool grays are spread among all the colors of the palette in multiple variations and help extend the ranges. Grays are the best complements for saturated colors because they make them stand out and help to harmonize the painting.

GRAYS WITH BLACK AND WHITE
The most obvious method of obtaining grays is to add a third color to a mixture of white and black. The result will be a gray with a warm or cool tendency (greenish, bluish, or reddish) according to the paint incorporated. Such grays are very unsaturated tonalities, and having only a small color component, they tend to be used as substitutes for pure white (when they are very light) or pure black (when they are very dark).

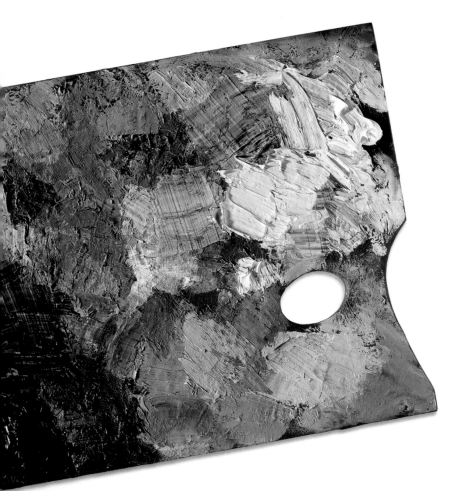

Taking them one by one, these colors are really all grays. Arranged together they form a small symphony of warm and cool, light and dark, reds, blues, browns, yellows, and so forth. Such is the power of grays to evoke all colors.

Between white and black, we encounter all the grays: all the colors that traverse the path between these two ends can be made into a gray. Gray is the natural end product of working with paint, the dross, but when used with talent it too can be a glorious color.

GRAYS WITHOUT BLACK AND WHITE

Grays can also be made by mixing two complementary colors (reds and greens, blues and oranges, yellows and violets). The result will always be a dark tone, with a warm or cool tendency according to the color that dominates the mixture. Normally, this tendency can be more easily seen by adding a little white to the mixture. These tones are also referred to as neutral colors.

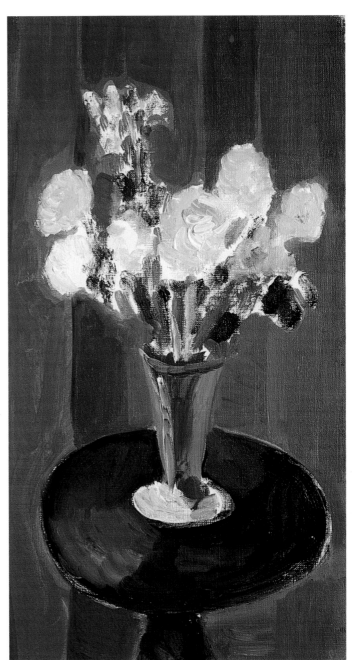

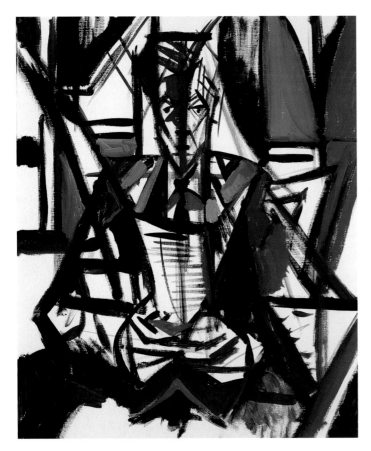

Grays promote order, composition, and the construction of the picture. They are "disciplined" colors that create sober and well-organized harmonies. Work by Yvan Mas.

Grays give extraordinary results when they accompany and surround very vibrant colors. They are the best complement of pure color. Work by David Sanmiguel.

The Palette and the Order
of the Colors

The palette is a traditional oil painting tool. It can be made of plastic or wood, square or oval shaped, and in different sizes. A medium size, square palette has a larger surface for mixing paint than an oval one. In the very large sizes, an oval is much more comfortable because its weight is distributed equally around the thumb. There are also paper palettes (pads of coated sheets of paper) that allow the artist to discard each sheet once it is filled up with mixed paint. Many artists use newsprint as a palette, since it is easy and disposable, or a glass or varnished wood surface placed on a table. In reality, any nonabsorbent surface will do.

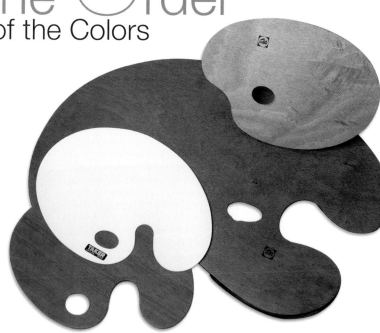

Oval palettes are more comfortable than squares for those painters that like to hold them in one hand while painting.

Some painters prefer use their colors sparingly and completely clean the palette after each session, leaving a large central area for mixing

Palette cups have a clip that allows them to be attached to the palette. This way the painter will always have at hand containers for solvent and, if necessary, an extra amount of oil for adding fluidity to the mixed paint.

ARRANGEMENT OF THE COLORS

Each artist arranges the colors on the palette in his or her own manner, according to how many there are and the way the artist works. Normally the warm colors are separated from the cool ones, and black and white are separated from all the others. Some use two whites, one for the warm colors and the other for the cool ones, which can be placed in the center of the palette. One possible arrangement would be to begin with the yellows, followed by the ochres, the reds and crimsons, the siennas, the greens, the umber tones, and end with the blues and violets.

The palette cup is a useful tool usually made of aluminum, that attaches to the palette to hold paint thinner. Some painters use two of them, one for the solvent and the other for refined linseed oil for reducing the viscosity of the colors. Others use only one cup by mixing the solvent with linseed oil to obtain a solvent with oily qualities and with more sheen. However, most artists prefer using larger containers. Some use several containers for thinner to keep from dirtying the paint mixtures. They use one container of thinner for the warm colors and another for the cool colors, yet another for the very light colors, and so forth.

The constant use of certain colors causes large accumulations of paint on the palette, which in turn creates an object full of significance for the artist. The paint on this palette consists of titanium white, cadmium yellow medium, yellow ochre, burnt sienna, cadmium red medium, red oxide, alizarin crimson, cobalt blue, ultramarine blue, viridian green, burnt umber, and black.

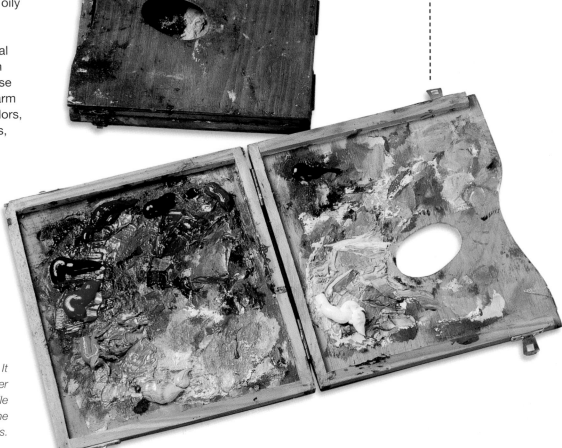

A palette made by the author. It consists of two halves that fold together and is ideal for transporting while keeping the paints from staining the other materials.

Brushes, Supports, 'and

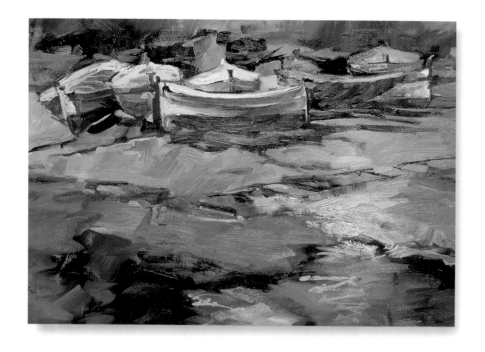

Solvents.

In addition to the
colors, no oil painter

can get along without these materials. Each one of them has a specific function, but it is not necessary to have all of them all the time. For the painter it might be enough to have a few colors, two or three brushes, and a decent support to paint on. However, it is important to be familiar with all the tools and their uses, to experiment with them, to see how the materials respond to your intentions, and how you respond to them. Over time your choice of tools will become instinctive.

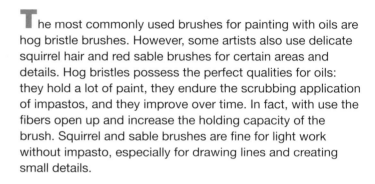

Brushes and
Painting Knives

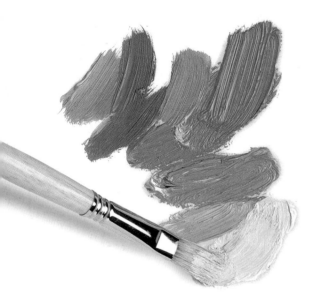

The bristles of the brush should be rigid enough to keep their shape while holding a lot of thick paint and rubbing it onto the canvas or mixing it.

The most commonly used brushes for painting with oils are hog bristle brushes. However, some artists also use delicate squirrel hair and red sable brushes for certain areas and details. Hog bristles possess the perfect qualities for oils: they hold a lot of paint, they endure the scrubbing application of impastos, and they improve over time. In fact, with use the fibers open up and increase the holding capacity of the brush. Squirrel and sable brushes are fine for light work without impasto, especially for drawing lines and creating small details.

ASSORTMENTS

Brushes come in three types based on the shape of the tip: round, flat, and filbert. The length of the tip is usually proportional to its diameter (between 15/64 inch [5 mm] for the smallest sable brushes and 2 inches [5 cm] for the thickest hog bristle brushes). While squirrel hair and sable brushes are not essential and can be substituted with synthetic hair brushes, some fine brushes are necessary, and it is best to have several of them in different shapes and sizes. Wide flat brushes, like those used for painting houses, are also useful for backgrounds and should be of good quality.

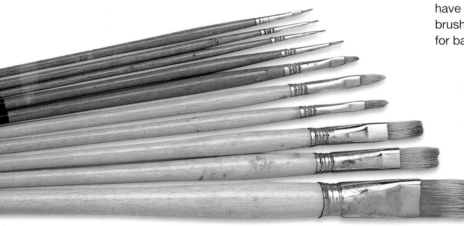

An assortment consisting of ten round and flat brushes of different sizes is more than enough for most work. A few wide brushes and fine hair brushes can be added for very delicate tasks.

Scrapers, or putty knives, are also useful for spreading large amounts of color.

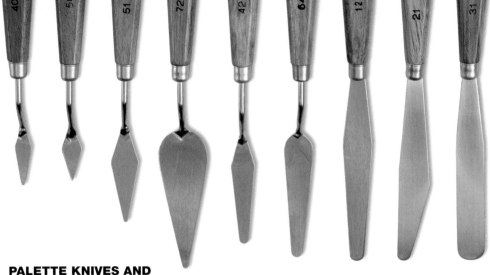

PALETTE KNIVES AND PAINTING KNIVES

Palette knives, have long, flexible blades joined directly to the handle and conveniently scrape the palette surface to clean it. Painting knives come in a variety of blade shapes and sizes that are offset from the handle by a bend in the shank. This offset allows the artist better access to the work by keeping fingers and knuckles out of wet paint surfaces. It is a good idea to have several painting knives in various shapes and sizes, including one with a wide blade for spreading large bases of perfectly smooth color. A plasterer's trowel also can be very useful for scraping paint and for applying impastos on the canvas. Working with oils can be quite messy. It is important to always have paper and old rags to clean your hands and clothing and for wiping and cleaning brushes.

CARE AND CLEANING

Brushes should be cleaned after every painting session. The most practical way to do this is to squeeze the excess paint from the bristles using a piece of newsprint. Then the bristles are washed with thinner to dissolve all the paint. This may not be enough to completely clean the bristles, and even if it was, they would be damaged by the corrosive effect of the paint thinner, so they must then be washed with soap and water.

A complete selection of palette and painting knives is available in art supply shops. The longest ones are very flexible and are used for dragging and scraping surfaces. The ones shaped like trowels are the most appropriate for applying paint.

It is useful to have a hog bristle brush for preparing canvasses, applying backgrounds, and other tasks of this kind. The brushes should be left in water for about 15 minutes before using them to keep them from losing bristles on the surface of the support.

This is a good solution for drying brushes and conserving them. By hanging them you avoid causing the ferrule to rust from the water used to clean them

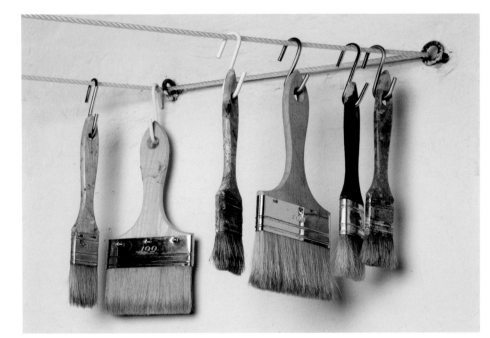

A

B

C

Linen (A), cotton
(B), and hemp (C)
fabrics are most
commonly used for
making supports.
Linen is the best
quality of the three.

Fabric and canvas are the traditional and most common supports used by painters. They are made from materials like linen, hemp, and cotton. The best quality fabrics are made of linen because they are fine and react well in humid environments (their tension does not vary too much in the humidity). They are also the most expensive, their price being based on the density of the linen threads. There are also fabrics that mix linen and cotton threads to lower the cost. Cotton fabrics are the most widely used. Finally, hemp cloth is heavier, and burlap is the heaviest of all, appropriate for use with large impastos.

Supports:
Fabric

OTHER SUPPORTS
Cardboard is used by many painters for making sketches and color studies. It has the drawback of being excessively absorbent, which over time can cause serious flaws in the surface of the paint. This can be avoided by priming with a coat of glue or gesso. Any cardboard may be used as long as it is not too absorbent. The manufacturers of art materials sell canvas boards, made specifically for oil painting.

Although it is not as absorbent as cardboard, wood also requires a coat of primer, such as gesso for example.

The problems presented by paper are the blotches and yellowing caused by oil absorption. An oil painting on paper is usually matte, although proper preparation of the surface with acrylic or gesso is a good solution for this problem. Nowadays, there are special papers for painting with oils that resolve all these problems.

TEXTURES
The texture of the fabric depends on the weave and its preparation. A high-quality linen has a very fine texture and good weight. Some artists prefer fabrics with more texture, and certain manufacturers offer fabrics with considerable texture.

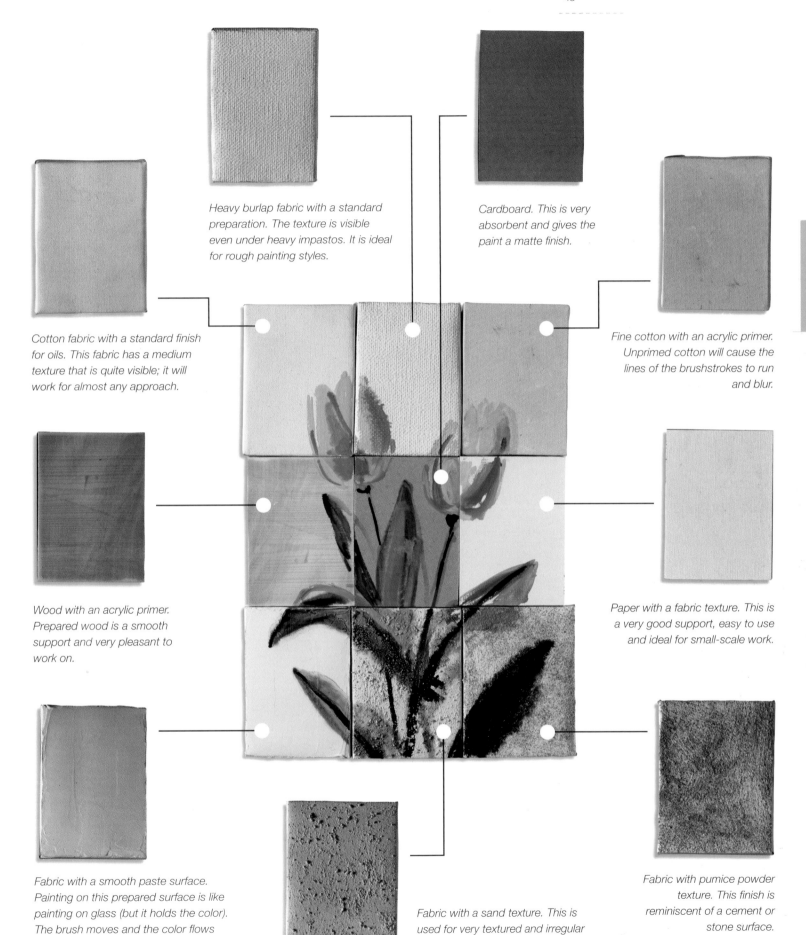

Heavy burlap fabric with a standard preparation. The texture is visible even under heavy impastos. It is ideal for rough painting styles.

Cardboard. This is very absorbent and gives the paint a matte finish.

Cotton fabric with a standard finish for oils. This fabric has a medium texture that is quite visible; it will work for almost any approach.

Fine cotton with an acrylic primer. Unprimed cotton will cause the lines of the brushstrokes to run and blur.

Wood with an acrylic primer. Prepared wood is a smooth support and very pleasant to work on.

Paper with a fabric texture. This is a very good support, easy to use and ideal for small-scale work.

Fabric with a smooth paste surface. Painting on this prepared surface is like painting on glass (but it holds the color). The brush moves and the color flows like in a watercolor.

Fabric with a sand texture. This is used for very textured and irregular effects.

Fabric with pumice powder texture. This finish is reminiscent of a cement or stone surface.

Supports and the Consistency
of the Paint

The adaptability of oil paint to the most diverse supports causes the final results to vary enormously according to the surface on which you are painting. Rough or smooth, glossy or matte, absorbent or not, these and other alternative surfaces will determine the results. It is not possible to say which is the most recommended because if the paint adheres well to the support all of them can be ideal for different kinds of paintings. On the following pages several examples of very different types are shown. In them you can see how each surface emphasizes certain characteristics of the oil paint and plays down others. Keep in mind that all these examples, done by David Sanmiguel, are painted on bases that were specially prepared with quality primers.

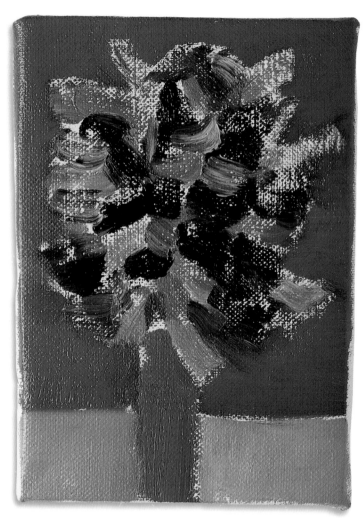

A standard preparation is very good for working with medium consistency. The texture helps the paint shine, and the colors are lively.

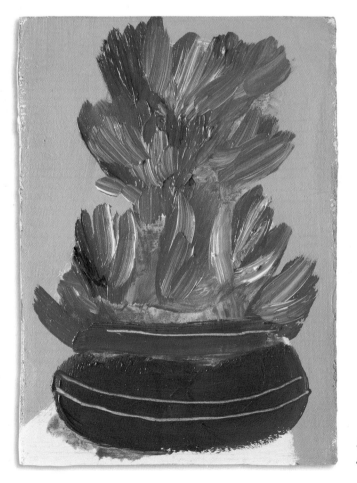

Smooth surfaces are excellent supports when the goal is to contrast areas of flat color with areas of impasto

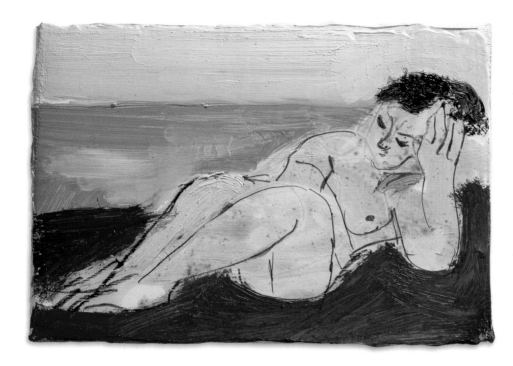

Paper and fabric with a very fine texture favor clean treatments with well-defined edges. They are ideal for artwork requiring line work and precise contours.

A satin finish will add a delicacy to the colors and works well with strokes of very diluted paint.

Unprimed canvas produces very atmospheric and blurred results where details seem to disappear.

Textured supports emphasize the flatness of the fabric, and the finishes are reminiscent of mosaics and frescos.

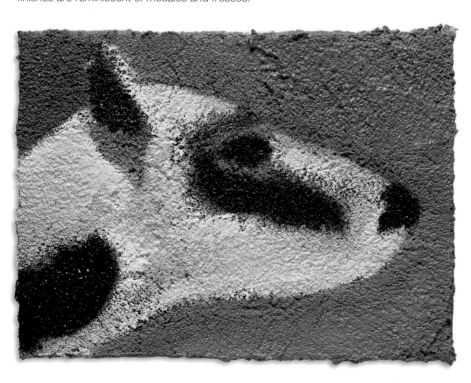

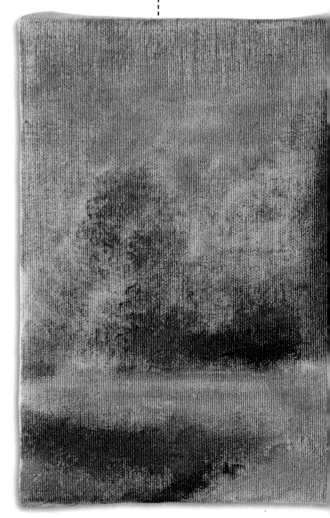

Solvents, Mediums, and Dryers

A

B

C

Turpentine, or essence of turpentine, is a solvent frequently used by oil painters. It is produced by distilling pine resin and is transparent though slightly yellow, with a strong penetrating odor (resin odor) that bothers some people and is aromatic for others. It is harmful if ingested, and most likely, long exposure to the vapors is also harmful; it will irritate the skin. Because of these characteristics and because there are several alternatives, its use is not at all recommended.

All petroleum distillates will dissolve oil paint. Mineral spirits is also commonly used as a solvent. It is transparent and odorless, less toxic than turpentine, and less of an irritant. Another, more pleasant, alternative is distilled from orange peel: a good solvent and very aromatic, but quite a bit more expensive than the others.

However, all solvents have a certain amount of toxicity and should be used in a well-ventilated area.

A. Mediums make the paint more fluid, increase its volume, and barely alter its color.

B. Oil dilutes the paint without altering its color and increases its transparency.

C. Solvent dilutes the paint and breaks it up if used excessively.

Vegetable- and mineral-based solvents. From left to right: rectified turpentine, conventional turpentine, and mineral spirits (white spirit). Turpentine is commonly used because of its low cost.

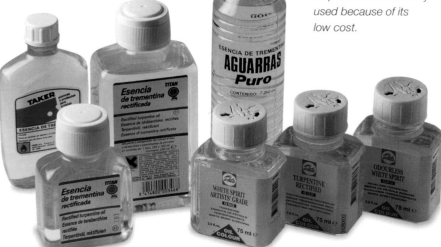

A small amount of paint straight from the tube can be left on newsprint for a couple of days to reduce the amount of oil in it. The paper will absorb the oil and the paint will become thicker and less oily.

MEDIUMS AND VARNISH

The artist can use oil mediums and varnish to dilute colors, make them more fluid, retouch them, to glaze them, and so forth. Linseed oil is the binder (agglutinate) of the oil paint itself; it brightens the colors and makes the brushstrokes more fluid. It is usually mixed with a little turpentine. Poppy seed oil is less likely to bleed than is an excess of linseed oil, but it dries more slowly; it is usually used for applying thin glazes. Walnut oil is more fluid and is appropriate for very meticulous and detailed styles. The most widely used oil for painting is turpentine; this popular solvent gives the best results.

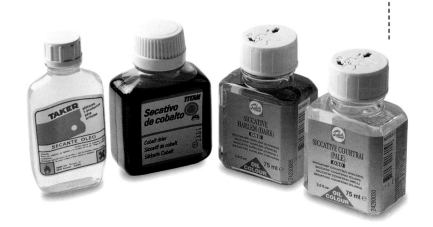

Drying mediums. From left to right: universal drier, cobalt drier, Siccatif de Harlem (dark), and Siccatif de Courtrai (pale). All driers must be used sparingly and with extreme caution.

Used solvents can be recycled by successively pouring them into different containers as the impurities are deposited at the bottom.

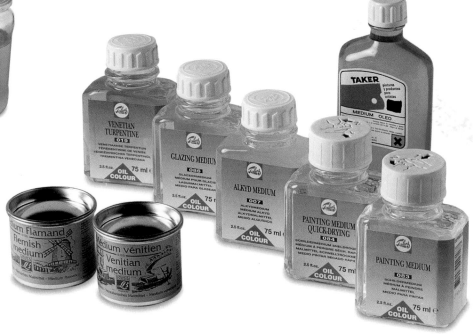

Oil mediums, from left to right: Flemish medium, Venetian medium, Venetian turpentine, glazing medium, alkyd medium, quick-drying medium, painting medium, and oil painting medium.

Making
a Wax Medium

Continued practice and experience are the best counsel for the painter—even more so if he or she is using oil paint, since their "recipes" are richer and more complex. In the section on mediums, we talk about more variations and alternatives to the use of solvent. Most painters add oil to the solvent to increase the glossiness of the color and soften the brushstrokes. Many of them manufacture some special medium for modifying and enriching the texture of the paint and the consistency of the finish on the artwork. On the following pages we will demonstrate the making of a medium based on beeswax. Wax, because it is oily, combines with oil paint very well. Its texture and translucent quality adds interest and sensuality to a particular work of art.

1. The ingredients for making a wax medium: turpentine, rosin, and pure beeswax.

2. First, the rosin is crushed by wrapping a few chunks in a rag and striking it with a hammer.

3. The rosin is then wrapped in cheesecloth or nylon fabric and placed in turpentine to dissolve.

MANUFACTURING PROCESS

The ingredients of this medium are rectified turpentine, beeswax (yellow, not white like paraffin), and rosin. Rosin is a natural resin that comes in small amber-colored chunks that still is listed as an ingredient in many recipes for making paint. A few chunks of rosin are wrapped in a cloth and crushed with a hammer to obtain very fine granules. This handful of rosin is then wrapped in nylon mesh and placed in a jar with five parts turpentine per one part rosin. The turpentine will dissolve the rosin, and the nylon mesh should be fine enough so that the impurities contained in the rosin pieces are trapped and do not pass through to the liquid. When all the rosin has dissolved in the turpentine, a piece of pure beeswax is added (one part wax to six or seven parts rosin), and the mixture is heated in a double boiler until the wax is completely melted. The resulting paste is preserved in a tightly sealed jar so it will not harden and will be readily available to the artist when he or she needs it. Small amounts of this medium are mixed with paint (approximately a full brush of paint for half as much medium) as the painting is being done.

4. A piece of wax is added to the resulting liquid, which is then heated in a double boiler.

5. The mixture should have a creamy consistency similar to that of honey.

This painting was done using a wax medium similar to the one explained on this page. The finish has a very attractive translucent quality, and the colors have depth. Work by Joan Gispert.

Notice in this detail the rich, soft blends and clearness of the color achieved by the homemade wax medium.

Paint-ing

The Technical Process

"ONE COMES TO NATURE FULL OF THEORIES AND NATURE IMMEDIATELY
CRUSHES THEM."
Pierre-Auguste Renoir (1841-1919)

The Process of Creating

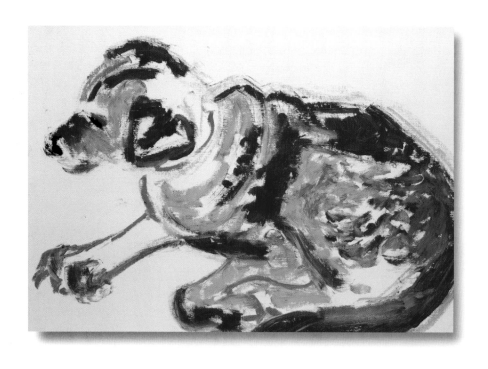

DAVID SANMIGUEL. HUNTING DOG, 2006.
OIL ON CANVAS

a Painting.
Oil paint
can be used

in a certain manner to avoid unnecessary errors and complications. It is not a matter of a complex catalogue of recipes, but of simple steps to which we should pay attention. This process is dictated by the lengthy drying time of the paint, which causes some physical (and chemical) changes from the time it leaves the tube until it is completely dry. The artist should carefully consider the concepts that are explained on the following pages so that these changes will not damage the painted surface in the near or distant future.

From the Drawing
to Color

Skill in drawing is a primary requirement for artistic work. Drawing is, above all, composition, the organization of the forms in the subject. Color will later add its expressive power to this organization to the degree desired, but it is always informed by the drawing. The drawing made for an oil painting (usually done with charcoal) should be spare and simple in detail. A few lines are enough to approximately define the outline, the size, and the placement of each form. These lines may be sprayed with a fixative, if the color work is expected to be delicate, or left as is, if the artist plans to use opaque color from the beginning.

DILUTED OIL

The essential manner of working in oils dictates that we must first use diluted colors and then thicker paint. The color lightened with turpentine dries more quickly than color that is rich in oil; if the latter is applied first the surface of the painting will eventually form cracks. This means the work should transition from thinner to thicker paint and to finish with applications of impasto. However, many artists prefer a light finish, like watercolor, with brushstrokes of color that allow the color of the canvas to show through. In these cases, a lot of solvent should be used, and thicker color applied as a final touch. Such paintings, however, do not have the luminosity and the colorful qualities of a watercolor. Diluted oils do not work very well, and the color may break up if too much solvent is used. But as a first phase in the creation of an oil painting the oil "wash" is nearly inevitable and can turn out to be very interesting, as seen in the illustrations here.

In this drawing very light brush lines are painted over charcoal lines. The initial drawing must be very simple for the color wash to be of quality.

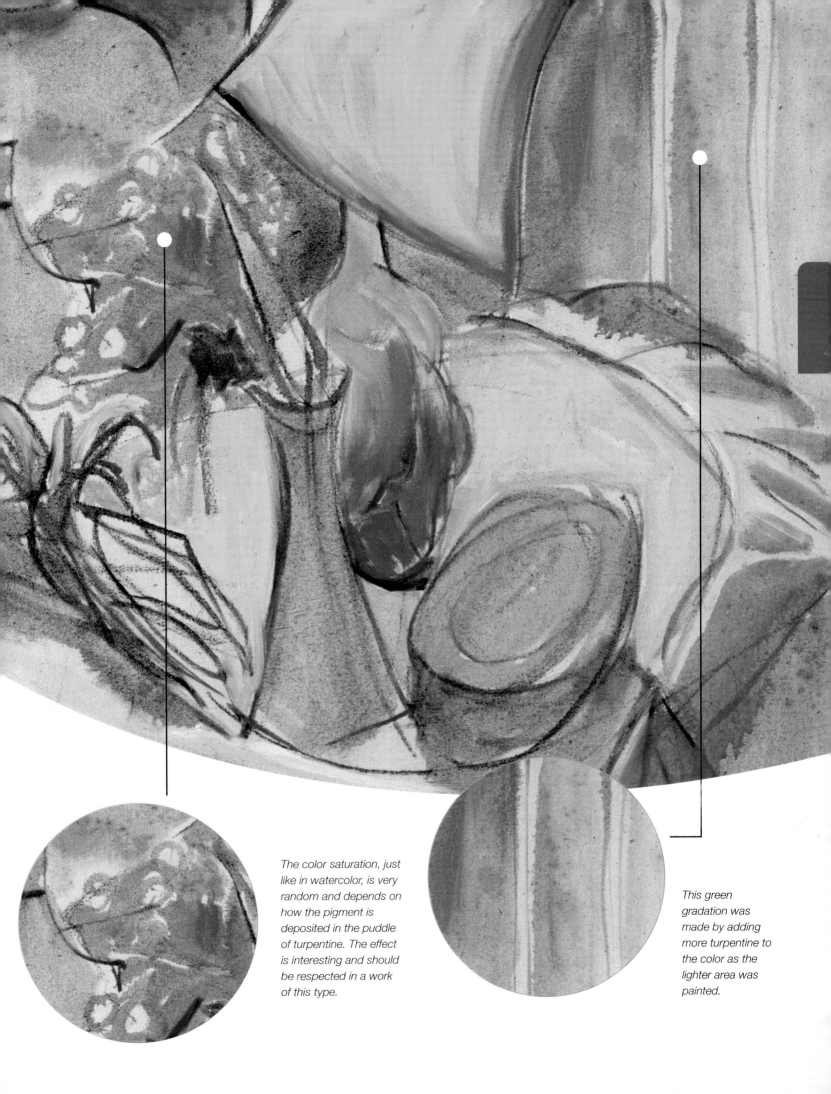

The color saturation, just like in watercolor, is very random and depends on how the pigment is deposited in the puddle of turpentine. The effect is interesting and should be respected in a work of this type.

This green gradation was made by adding more turpentine to the color as the lighter area was painted.

A watercolor look can be the result of a quick study carried out in a few working sessions, or of a slow approach, but in either, the artist erases and corrects the painting with rags and turpentine with the goal of preserving the freshness of the new brushstrokes. This is equivalent to working in watercolor but with the ability to correct and the added possibility of opaque colors and even impasto in the final phases of the work. However, from the beginning, using the thinned colors, it is possible to put into practice the usual techniques of oil painting (modeling, shading, mixing colors, and so forth).

The points of reflected light are areas where the painter rubbed a brush dipped in pure solvent; the color was diluted enough so that the white of the canvas was restored.

Different Dilutions
of Color

TRANSPARENT AND OPAQUE COLORS

All colors that are diluted in solvent are to a greater or lesser degree transparent. To make the less transparent ones more opaque it is enough to make the paint thicker. In every case, colors can be made opaque by mixing them with white. On the following pages a still life done with very thinned paint is shown and studied. The artist, Óscar Sanchís, modeled the fruit without having to use thick and covering paint. Notice that some colors, such as yellow and crimson, are much more transparent than others (such as the reds). This working style, without "laying on the paint," is the most effortless way to approach the process of oil painting.

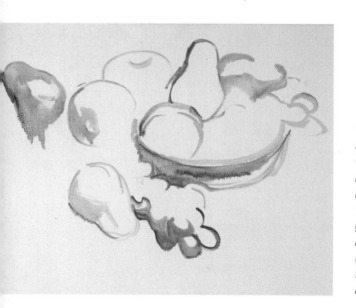

When attempting to do work based on very light brushstrokes, it is best that the "drawing" be a grouping of lines in a neutral color (blue, in this case) thinned with a large amount of solvent.

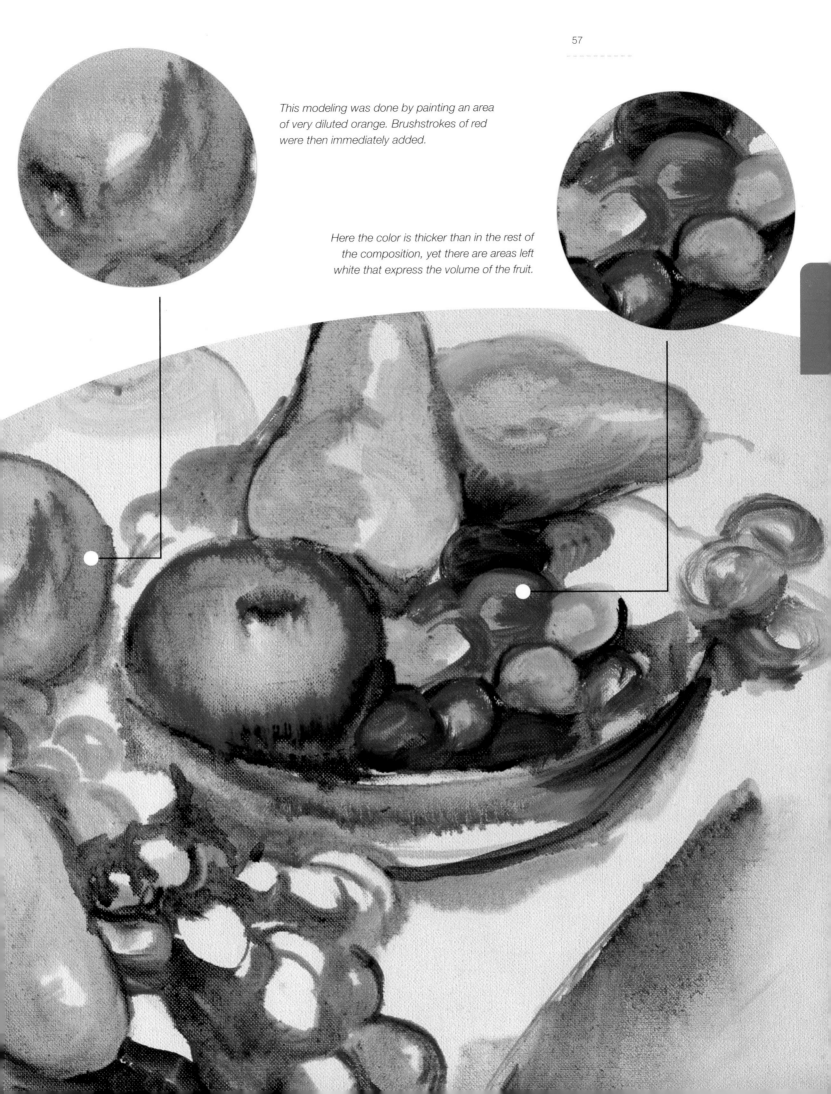

This modeling was done by painting an area of very diluted orange. Brushstrokes of red were then immediately added.

Here the color is thicker than in the rest of the composition, yet there are areas left white that express the volume of the fruit.

Heavy
Color

Even though the color may be the same, its appearance will vary according to whether it is thick or thinned with solvent. This is one of the most peculiar characteristics of oil paint, and one that causes it to be a technique with many variations and possibilities. The areas of color depend not only on the color itself but also on its consistency. A rich impasto has a solid and saturated surface color that is valued as much for the richness of tone as for that of the material. Now, value requires contrast, and to highlight the areas of color impasto, we must juxtapose them with other areas of light, thinned color, or at least other areas that have an impasto with different qualities.

IMPASTO AND BRUSHSTROKES

By impasto we mean applications of thick color, undiluted with turpentine. Impasto applied with brushstrokes creates a characteristic texture, furrowed and irregular that can be more or less abrupt according to the amount of oil used to apply the paint (more or less "dry"). In the images on these pages, we witness the creation of a still life using thick color from the beginning, but not impasto. The artist uses a wax medium (explained earlier) that adds a fluidity and creaminess to the brushstrokes of barely diluted color. This medium permits us to work with covering color that is not excessively thick, and the work of art is developed as if it were a sketch, in a fresh and direct manner.

The simple construction of the grapes (barely two strokes, blue and white, for each of them) speaks of economy of means and the clear vision of the artist. Its sketchiness is in perfect harmony with the overall simplicity of the work.

The applied color was quite thick and creamy but was not impasto; the texture of the finish is rich but discreet and moderate.

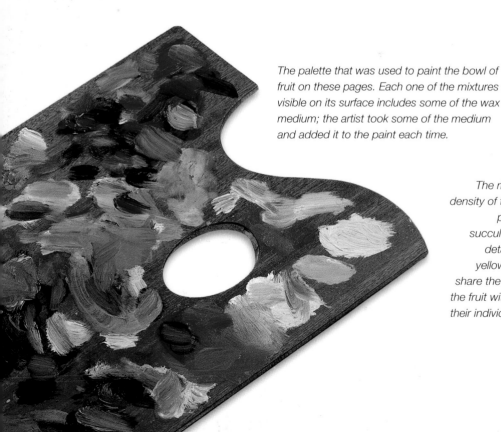

The palette that was used to paint the bowl of fruit on these pages. Each one of the mixtures visible on its surface includes some of the wax medium; the artist took some of the medium and added it to the paint each time.

The richness and density of the color is particularly succulent in this detail: ochre, yellow, and red share the surface of the fruit without losing their individual qualities.

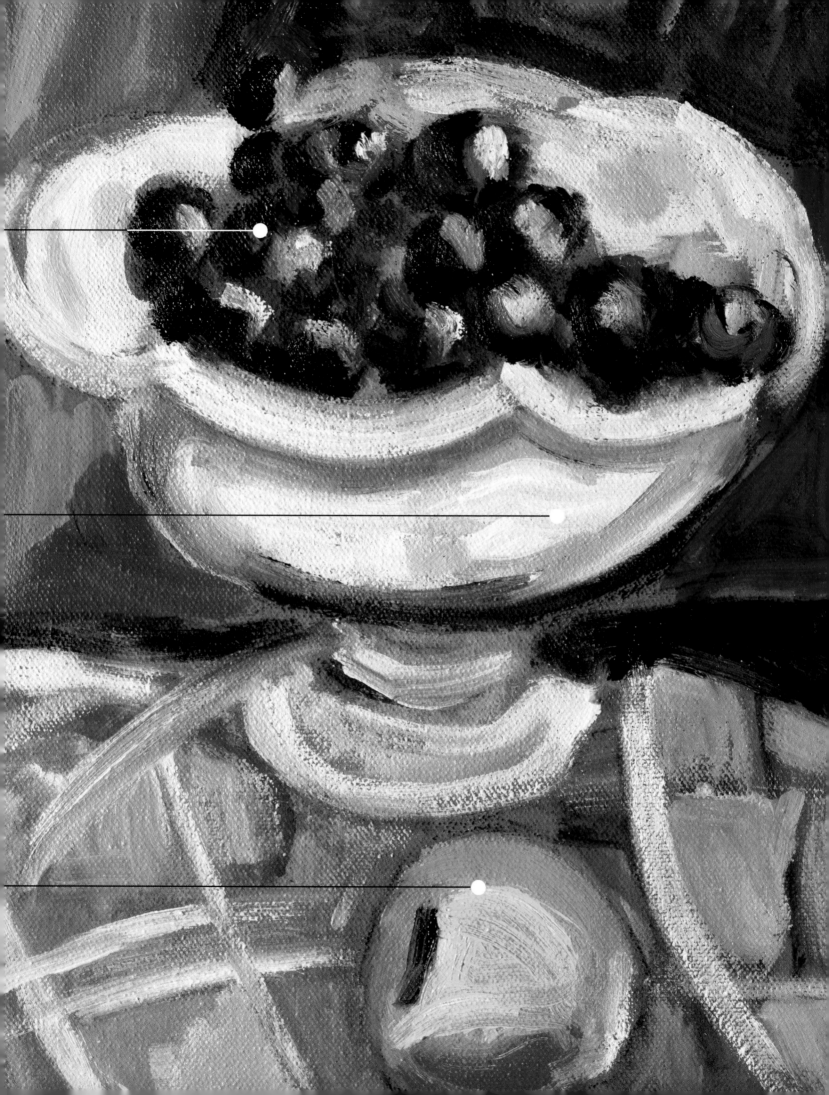

From Light
to Heavy

The example that is reproduced on these pages is a typical sample of the oil painting process: We first paint with colors that are very diluted with solvent and then continue with thicker colors painted over the first ones. Normally the first colors are quite neutral, that is to say, done using a very limited range of colors to define the light and dark values rather than the actual colors of the subject. Some artists begin their work with a grisaille in a cool color (a violet or crimson with a little blue) to define the outline and lay in the shadows. The oil painting process begins with dark colors and works toward the light ones, the opposite of watercolors. Therefore the initial sketch takes into account the shadows in the composition, leaving the resolution of the light for more advanced phases of the work.

1

1. This painting was drawn with the tip of a brush in a very loose style, as if it were a quick sketch or study, spontaneous and uncomplicated.

2

2. This is the grisaille phase. The landscape is laid out as a series of lights and darks all indicated with the same color, burnt umber with a bit of yellow. All aspects of the picture are resolved except the color, which will be added during the next phase with much thicker paint.

3

FROM GRISAILLE TO COLOR

The oil paint's opacity makes it easy to modify any brushstroke at any time, either by covering it with a different color or mixing it with another. The initial shaded sketch slowly changes from grisaille to color, a result of successive applications of color that are more correct and representative of the subject matter. But the color not only represents the tones of the different areas, it also gives form as the painter makes and modifies each area, fixing and adjusting the outlines in a process of truly building the motif.

3. Although colors and shadows have been added, the tonal arrangement of this part of the painting has not changed since it was laid out at the beginning.

4. This painting by Yvan Mas began as grisaille work. All the light and shadows were resolved first, and finishing the painting consisted of translating the values into these colors.

4

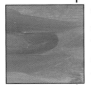

The sky was added at the end and was not worked on at all during the first phase. You can see how quick brushstrokes of thick paint spontaneously create light and dark areas depending on the amount of blue and white used.

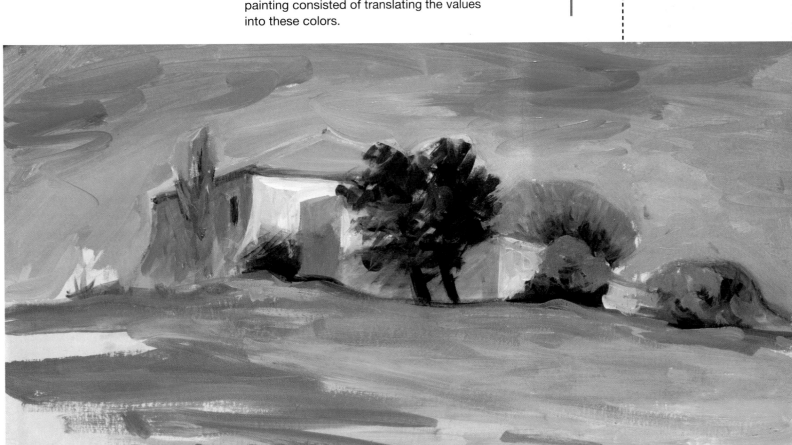

Direct Impasto

Not all of oil painting is preparations and layers and one session after another. Sometimes it is convenient to forget all that and paint with oil like you would paint with a simple uncomplicated medium—taking a few colors and applying them without looking back, little mixing and heavy brushstrokes from the beginning. In the example shown on these pages, the artist starts working without a previous sketch, forming and coloring each leaf and flower directly without worrying about making a mistake. Working this way gives the painting a certain freshness, especially when you wish to create a representation without the effects of light and space that complicate the task.

THE PICTORIAL PROCESS

With no drawing or previous marks, the artist applies brushstrokes that from the beginning describe the final form of the subject. He or she deliberately creates a rustic finish and does so without following the normal process of diluted color and thick color. The goal of the painter is not to create a complex and finished painting, but to achieve a work of art that is interesting for its color, composition, contrasts, the interpretation of the forms of the objects, and so on. This does not mean that mixing should be avoided, but there should not be a lot of it, and it can be done right on the canvas by applying dense colors over each other and allowing the brushstroke to find the right shade.

2. The paint is applied thick, without any solvent, and the artist builds up the thickness each time he or she adds a shade, lightens a color, or reinforces a shadow.

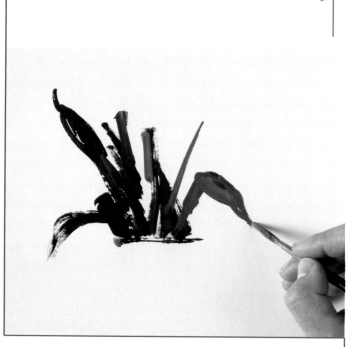

1

1. This vase of flowers was painted without any preliminary drawing. The leaves, flowers, and vase were formed directly with the paint, just as a watercolorist would make a quick study.

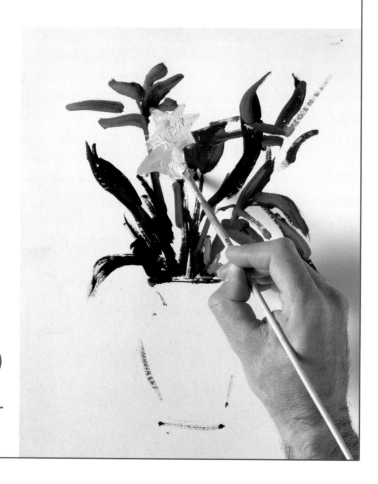

2

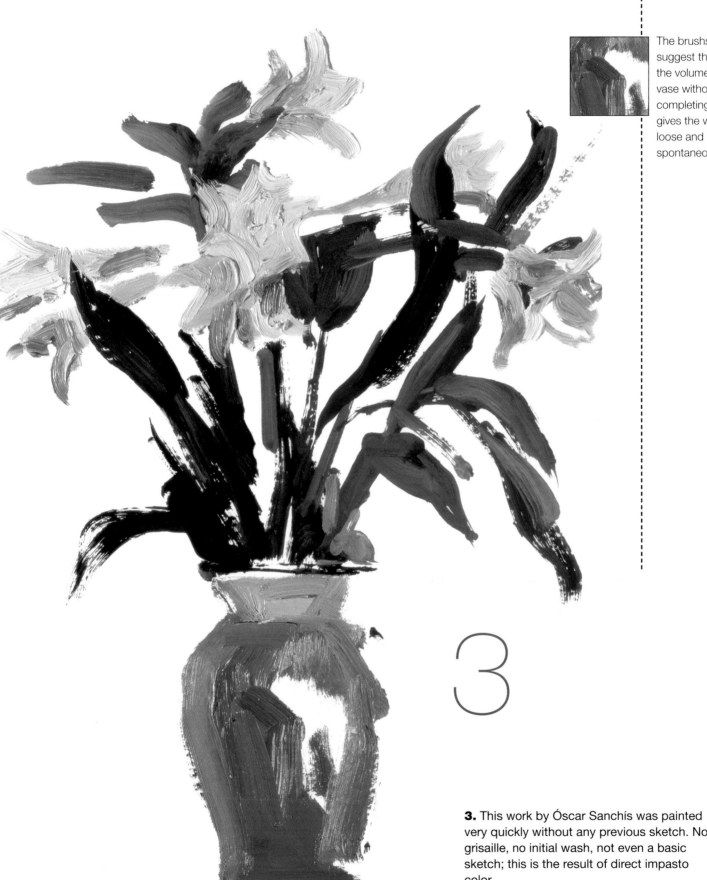

The brushstrokes suggest the form and the volume of the vase without completing it, which gives the work a loose and spontaneous feeling.

3

3. This work by Óscar Sanchís was painted very quickly without any previous sketch. No grisaille, no initial wash, not even a basic sketch; this is the result of direct impasto color.

Light and Color

Modeling and Blending

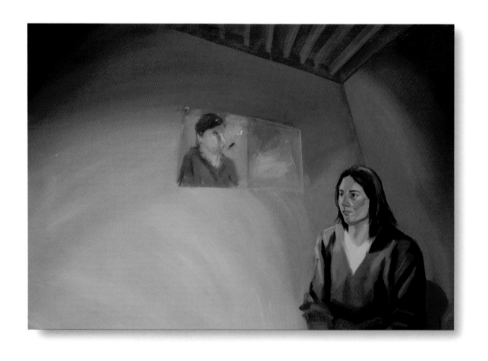

Colors.
One of the greatest
advantages of oil paints

is that the artist can give objects weight to make them truly solid and tactile. Modeling with saturated color encourages rounded and very defined volumes that sit solidly in the composition. The result is a chiaroscuro painting where the colors blend into each other; in other words a painting of juxtaposed masses located in a deep space.

Modeling
the Volumes

One of the great virtues of oil paint is that the colors can be modeled by blending brushstrokes with each other. This allows the painter to create surfaces where one color transforms into another without breaks or hard edges. The most immediate example of this is chiaroscuro modeling, a tone that passes from light to dark (and vice versa) creating a three-dimensional feeling. Here is found the root of realist painting, demonstrated with oil paint. The forms seem real and can almost be "touched," as if they are coming out of the surface of the canvas. On these pages we develop the modeling of a jar in two different ways, one using completely blended colors and the other with heavy impasto that leads to a similar effect while maintaining the individuality of each brushstroke.

When modeling by blending the color, the brushstrokes disappear because they are repeatedly smoothed. The light and dark tones blend in a continuous transition without breaks. This is achieved by brushing the creamy paint over and over.

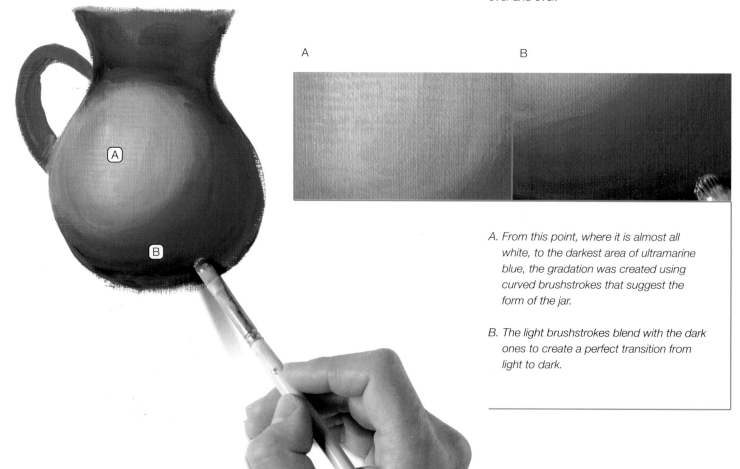

A. *From this point, where it is almost all white, to the darkest area of ultramarine blue, the gradation was created using curved brushstrokes that suggest the form of the jar.*

B. *The light brushstrokes blend with the dark ones to create a perfect transition from light to dark.*

IMPASTO AND BLENDING COLOR

Impasto can present a problem for painters that practice modeling by blending colors, that is, going from one color to another by mixing them on the canvas. If all this blending is carried out with a lot of paint, the work can end up having a pasty appearance, without chromatic strength and plasticity. Most artists that model by blending colors try not to overdo the impastos and work using little paint and loosely applied color. They never model the entire surface of the canvas, and they leave some areas of flat or barely modeled color.

1. Modeling without completely blending the color consists of creating the effect of volume by applying discontinuous strokes of light and dark color. The brush does not blend one color with another but lets the paint "live" to suggest relief. This approach, like that of modeling by blending, should begin with the dark colors.

2. The result of modeling without blending is much more energetic and less meticulous than modeling by blending brushstrokes. Each stroke should be applied in harmony with the rest of the painting. Work by Óscar Sanchís.

Blending colors and modeling in general is one more approach in the range of techniques available to the artist. In the colorist technique, modeling is avoided and replaced by juxtaposing bright colors.

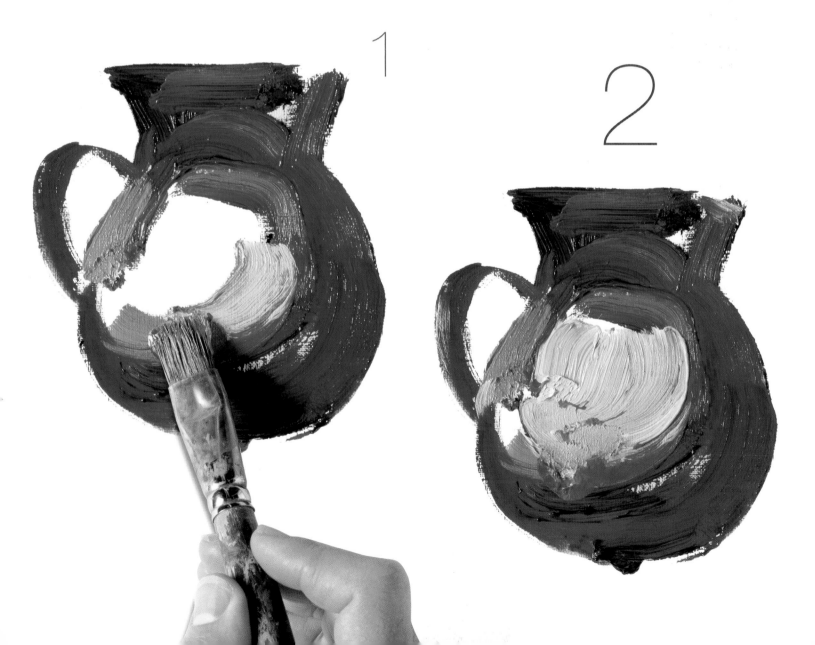

1

2

From Dark to Light

To achieve acceptable modeling, and generally speaking, to create a true chiaroscuro effect, the paint must always be applied from dark to light. This is the only way to control the values because it begins with the maximum amount of contrast, which can be attenuated as much as one likes with the addition of lighter shades. In this way oil painting is completely opposite from watercolor, in which the painter works from light to dark. To show this in practice, simply illustrated, the process of chiaroscuro modeling is depicted on these pages using a main shape (a fruit bowl) that is white. The modeling will be practically in black and white, beginning with the darkest values and working toward the lightest.

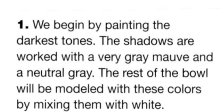

1

2

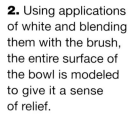

1. We begin by painting the darkest tones. The shadows are worked with a very gray mauve and a neutral gray. The rest of the bowl will be modeled with these colors by mixing them with white.

2. Using applications of white and blending them with the brush, the entire surface of the bowl is modeled to give it a sense of relief.

DETAILS OF THE PROCESS

Here we are most interested in the mechanics of modeling, and those mechanics can be more clearly seen when no color is used. The fruit bowl will help us understand how to go from dark values to light ones. This is done by progressively adding white to the mix, starting with dark strokes with enough middle values to make the surface seem continuous and unbroken. Values are light and dark intensities and exist in the grays as well as in colors; colors also vary in value, in lightness and darkness. When we speak of light and dark brushstrokes, we are also speaking about light; therefore, working with the values is working with the luminosity of the painting.

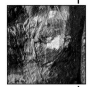

The unique texture of the impastos results from working with densely applied color. The painter strives for the richest possible color harmony with the most generous applications of pigment.

3

3. In the areas of cool light you can see the accumulated white paint. The highlights are always impastos.

4. The result is very realistic and creates a very convincing illusion of volume that is consistent with the style of the rest of the painting. Work by Óscar Sanchís.

4

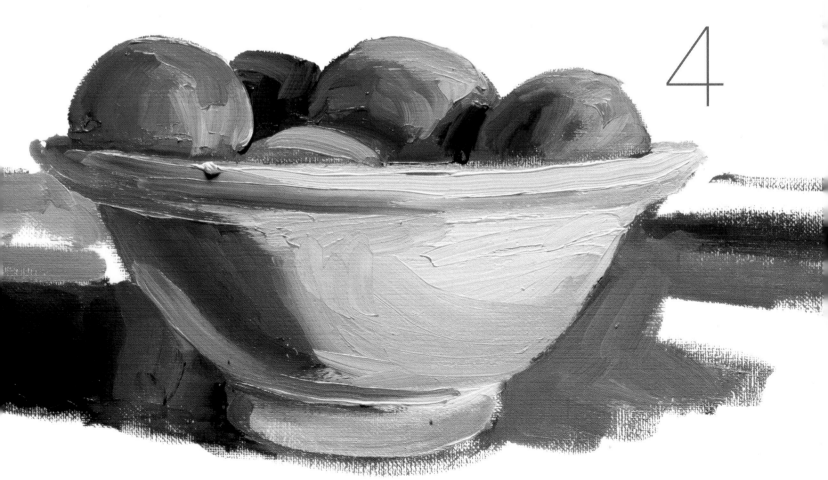

Modeling and Impasto
with Local Color

The colors of the elements themselves in a painting are the result of a visual habit; although colors vary greatly according to the light, our eyes tend to compensate for the differences and attribute a typical color to each object (the red of a cherry, the yellow of a lemon, a specific green to such and such a tree, and so on). Our name for this typical color is local color. One of the principles of realistic painting is fidelity to local color, and lightening or darkening it with light and shadow. Being faithful to local color promotes the use of a limited range because it is a matter of combining the colors of the elements with darker shades, which always tend toward brown tones. Work based on local color therefore means combining contrasts of color (illuminated colors) with contrasts in value (the grays and browns).

The strength of the brushstroke stands out in the methodical modeling and suggests a much greater expressiveness than can be achieved by the mechanical application of blended colors. Work by Óscar Sanchís.

When working with a wide range of contrasting colors, the modeling should be reduced to a minimum to keep the dark tones from affecting the purity and integrity of the colors. Work by David Sanmiguel.

Modeling is mainly applicable to work with a "value" approach that does not show greatly contrasting planes of saturated color. In this work by Esther Olivé, the planes of color take the place of modeling.

MODELING AND LIGHT

The sensation of light in a painting is the product of carefully distributed values. Despite what it may seem, it will be no more intense if the painter juxtaposes very dark and very light tones than it will be if the subject has well-organized intermediate values, which are known as midtones. Thanks to these intermediate values, the movement of dark to light will be gradual and the subject will look natural and convincing.

Some of the examples shown here represent extreme light conditions, but they are resolved with a great amount of intermediate colors and values that are definitely responsible for the realistic effect.

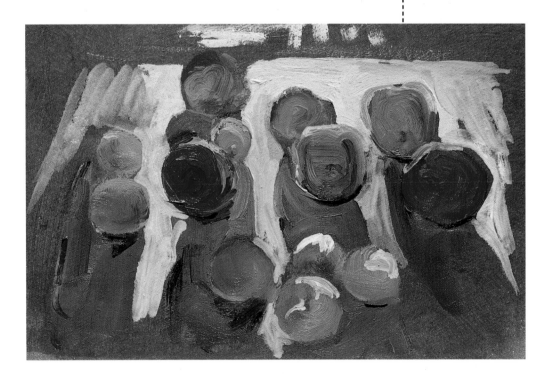

The modeling in this backlit painting must be combined with the abrupt shadows behind the pieces of fruit. The large gray brushstrokes create drama in the chiaroscuro. Work by Óscar Sanchís.

Blending, Value, and Space

The light and dark values, whether contrasting or found in a series of halftones, promote the definition of forms and their placement in space. It is sometimes enough to juxtapose a light brushstroke with a dark one to create a sense of distance; by themselves and without any additions, these colors are perceived as being on different planes.

The airy perspective, the atmosphere, is achieved by creating a smooth transition between these two extremes. In the landscape on these pages, that transition is made by blending, thereby creating a sense of depth caused by the contrasting values. The artist also uses these values to make the most important shapes in the painting stand out: a dark tree against a light sky or plain, or the opposite, a light element against a dark background.

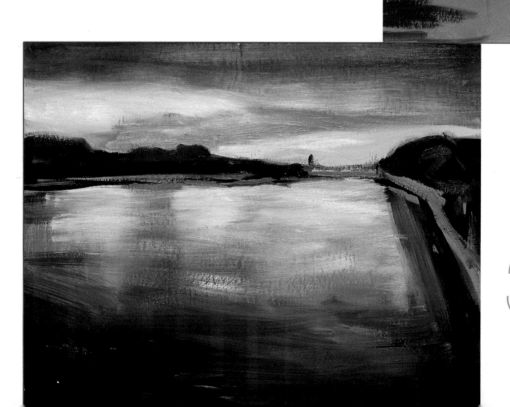

1. The blended color dominates everything else in this landscape, and the drawing is reduced to a minimum. The lines coming from the horizon organize the view.

2. The long vertical brushstrokes locate the main reflections on the surface of the water.

3. Sky and water are created with the same color range of blues shaded with a bit of crimson, along with the white needed to lighten the tones.

CHIAROSCURO LANDSCAPES

Contrasting values work for colors as well as for the grays. For a colorist painter, changing the values means finding different colors to represent the lights and darks rather than lightening and darkening the colors. One of the advantages offered by this chiaroscuro landscape is that it creates its own atmosphere in a very natural manner. The gradated background is enough to suggest a light-filled moment of the day with a particular quality in the air. This inspires painters that like atmospheric effects and airy perspective to make chiaroscuro landscapes. Color blending is a constant process, since the surface of the water should not be interrupted from the foreground to the horizon.

4. The darkness of the foreground reinforces the feeling of space. There is a smooth transition of lighter and lighter shades from the dark foreground to the light background that express very well the cool atmosphere of the dawn. Work by Yvan Mas.

Paint with a lot of oil and not much impasto is needed to create a good representation of the surface of the water, blending the edges of the brushstrokes to minimize the breaks between them.

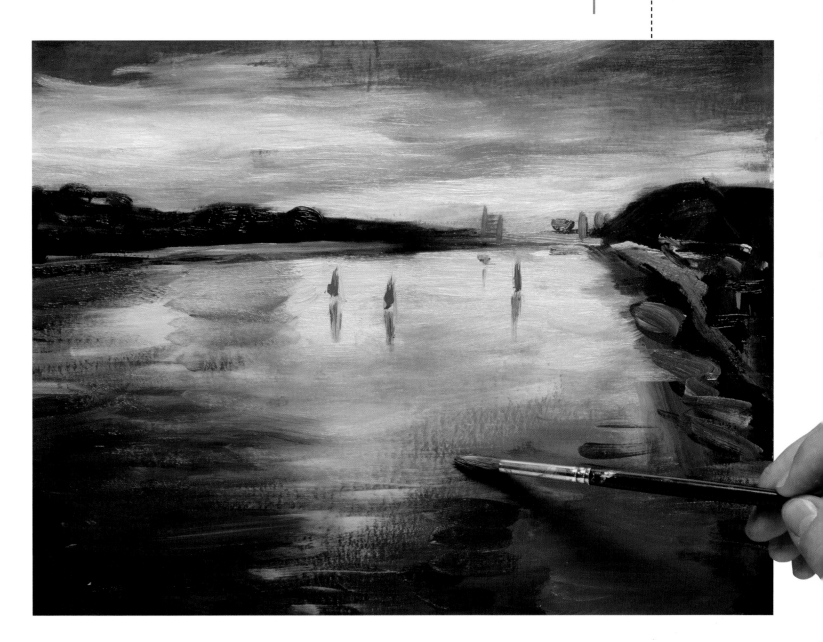

One visit to a museum with classical paintings is enough to confirm the curious fact that old paintings usually have a smooth surface, with smoothly blended colors and no indication of brushstrokes, especially when these works are compared to modern ones. The smoothness is partly owed to the many coats of varnish on the paintings that unify the surface. But it is mainly because the artists were very demanding when it came to the quality of their materials. Beginning with Impressionism, the evidence of brushstrokes became so popular that they became synonymous with modernism. The *avant garde* painter must show off the brush marks, the impasto, and the loose brushstroke. The tables turned, and clients preferred paintings with clearly visible brushstrokes. Based on this, the problem of the brushstroke is reduced to the matter of finish according to the tastes and styles of the moment. But there is a lot more to say about this.

Modeling without Blending
the Brushstrokes

COLOR BRUSHSTROKES
The size and direction of the brushstrokes can greatly affect the organization of the work of art. A painting created with wide strokes shows an artistic intention that is more concerned with organizing the objects with areas of color rather than with gradations of value, that is, with attempting a loose summing up of the subject using color. In such cases, the presence of brushstrokes in the finished work is not by chance, but something very important to the work of art. Their size and direction can vary, but they cannot blend with each other without destroying the integrity of the painting.

1

1. This drawing of a dog was made with an ochre color oil stick. It is a very simple drawing, based on a more or less continuous line. Ochre fits perfectly within the selected range of earth colors.

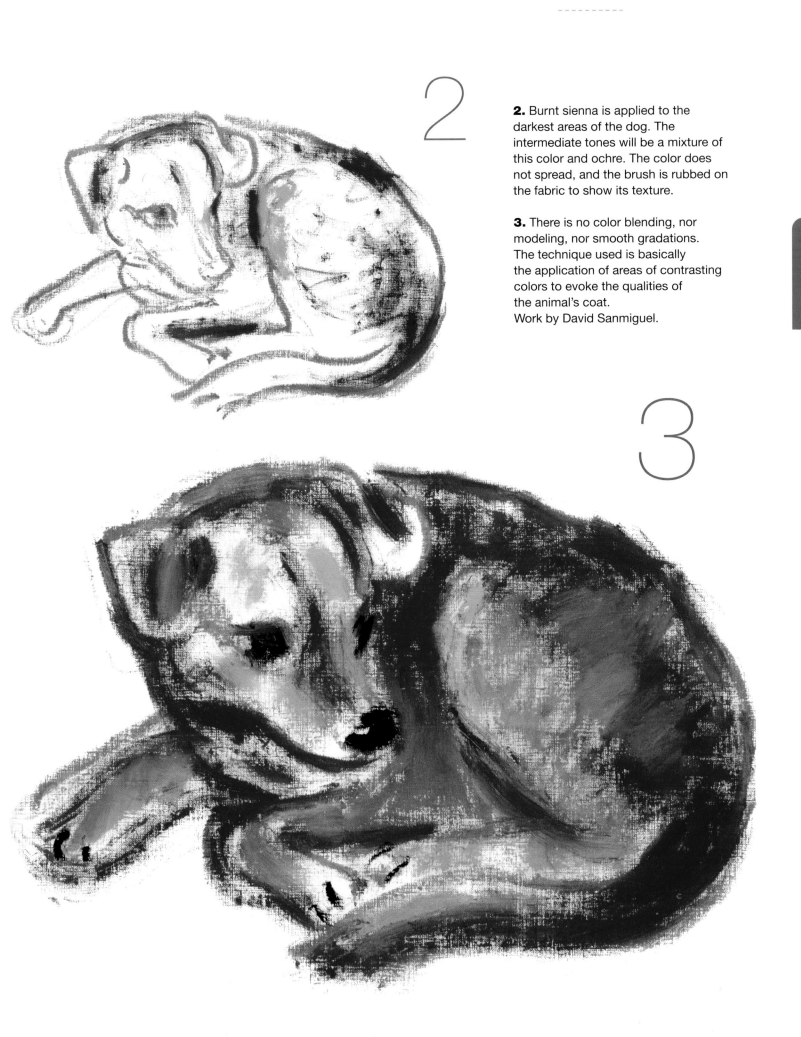

2. Burnt sienna is applied to the darkest areas of the dog. The intermediate tones will be a mixture of this color and ochre. The color does not spread, and the brush is rubbed on the fabric to show its texture.

3. There is no color blending, nor modeling, nor smooth gradations. The technique used is basically the application of areas of contrasting colors to evoke the qualities of the animal's coat.
Work by David Sanmiguel.

Light,
Color, and

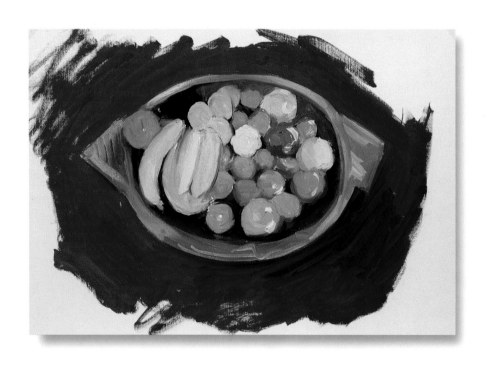

Subject Matter.
Care in the final finish

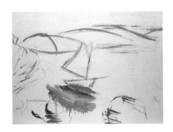

of a work of art is a matter that is related more to the artists' "craft," their experience or "know how," than to their creative imagination. Craftsmanship has always been part of the artist's work; sometimes it is more visible than others. However, this so-called craftsmanship is knowledge that is transmitted objectively, and it has standards that are the same for every craftsman. These standards are used for judging the finished pieces. One aspect of the painter's creativity is developing a personal craftsmanship that only affects the artist and that serves his or her imaginative abilities. These pages are an apprenticeship in the treatment of the painting's surface and of the objects depicted on it.

Light from Color

1

Representing light and color is the central challenge of chiaroscuro painting. It is a matter of lightening and darkening the local colors of the elements in the painting, always with a limited color palette, so that the contrasting light and dark tones (values) are emphasized and contrasting colors are greatly reduced. But when a colorist painter is using a full palette of colors and emphasizing color contrasts and rich tones (colors of all types), the game changes. A basic guideline for the colorist painter is that the color cannot be modeled. If the artist wishes to preserve the purity of the colors, he or she must represent the light using contrasts between the colors and not use modeling. Introducing modeling into a purely colorist work is a contradiction that sucks the life out of painting.

THE COLOR OF THE SHADOWS

The consequences of the previous paragraph are that the shadows and shading of a colorist painting are colors, not dark brushstrokes. The Impressionists discovered that such shadows are also light, less intense light but just as colored, and that the color is blue or a tone near blue. Another crucial discovery was the realization that the blue tone tended to be seen as the complementary color of the illuminated object. Keeping in mind these two basic facts about shadows (blue color, complementary color) will help guide the colorist point of view. In this painting you can see how the shades and shadow are either blue (the direct shadow of the vase) or complements of the green parts of the flowers (pinks and crimsons), spread across the background of the composition and very reduced with white so they will harmonize with other warmer colors.

2

1. The flowers in the vase were sketched in the simplest manner possible. The stems are long vertical brushstrokes. The flowers are directly applied brushstrokes, with no previous drawing, and the vase is two bands of color (warm yellow-gray and dark violet-gray, complementary colors).

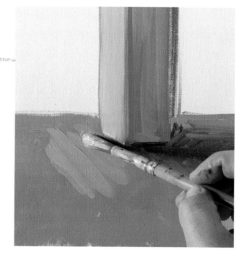

2. The tabletop plane is a very uniform light blue. This color was achieved by adding white to a cobalt blue base, carefully mixing with the brush to create the desired shade.

3. The table that the vase stands on is painted; then the background is painted with a color that is nearly identical to that of the illuminated side of the vase.

4. Pinks, greens, and violets, the dominant colors of the painting, are added to the background. The work takes on an atmospheric and very luminous coloration. Work by Yvan Mas.

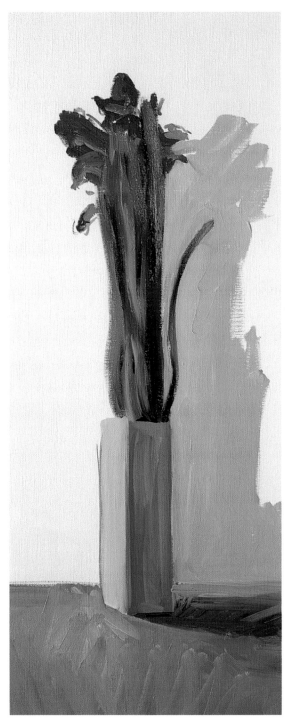

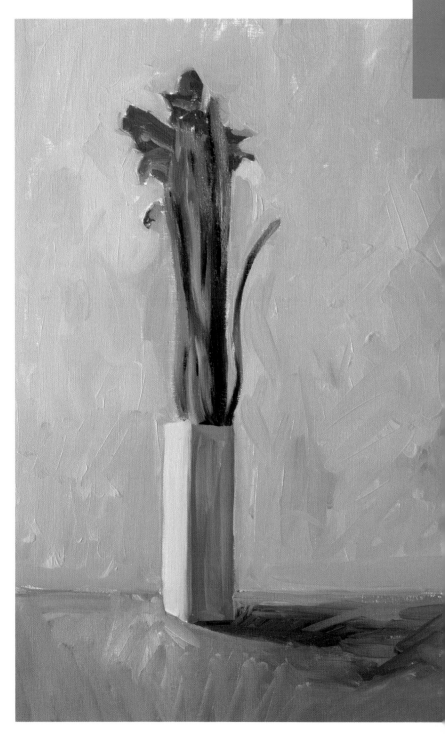

The relationship between line and color can be approached in different ways, but they almost always coincide at some point; forms are created by contrasting the different areas of color against each other. These areas of color may or may not align completely with the real subject, but ultimately those real contours are the ones that will determine the shapes of the bodies of color. A light area of color over a dark background provides some contours. In other words, it creates a form: subjects can be understood as areas of color (that is how many painters view them), so that that the artist can work with color and form at the same time. In the areas of the subject where no color contrasts are visible, there will be no chance of distinguishing the forms either.

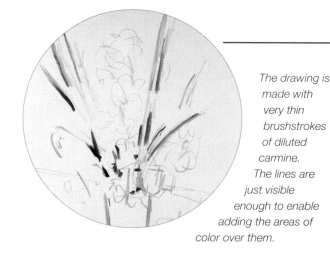

The drawing is made with very thin brushstrokes of diluted carmine. The lines are just visible enough to enable adding the areas of color over them.

The Brushstroke as
Drawing and Color

A "FABRIC" OF COLORS

When approaching a piece completely chromatically, paint is distributed as if it were a continuous fabric in which every color corresponds to a shape. In the case of a landscape with areas lacking detail (the water of a river or a lake, for example), the artist has to lessen the contrasts so that they do not create false contours that break up the water, thereby losing the look of a continuous body. But in a theme like this one, the colors on their own can represent very convincingly every single flower without the need for modeling, blending colors, or softening brushstrokes. The final result conveys freshness and luminosity, enhanced by the cool and soft colors that cover the background of the composition.

Ochres and yellows are the warmest colors of the palette, and pinks, mauves, and some cool tones, such as violet, can be placed among them very naturally. All of them are lively and fresh and create an appealing atmosphere in the painting.

The colors are applied thin, not concentrated: The paint should have the perfect creaminess for it to be opaque and to have good covering power without having to apply it too thickly, creating a heavy appearance.

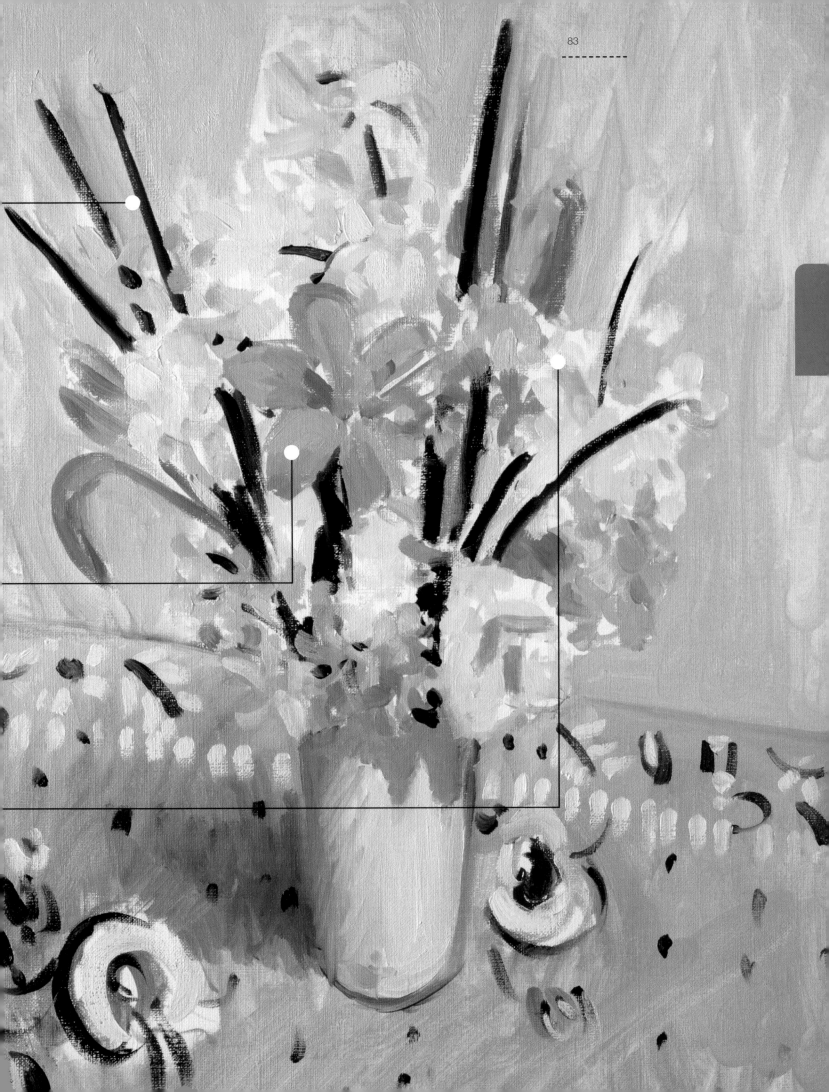

Color Harmony:
Warm Colors

Color contrasts, on their own, convey a spatial feeling. More precisely put: The contrast between two colors suggests some distance between them. There is always one that appears closer and the other farther away. This suggestion of distance increases when we put a warm color with a cool one; the warm one advances while the cool one recedes. Every artist is aware of this fact and uses it in his or her work. If we wish to place a shape in the very close foreground, we can paint it with a bright warm color (for example yellow or orange) and contrast it with surrounding cool colors. Those cool colors will visually recede away from us. This is a way to create space without using chiaroscuro.

1

2

1. This piece can be painted on a piece of cardboard covered with iron red oxide. This very warm color is part of the chromatic group made up of ochres and blacks. From the beginning, the areas left unpainted will go very well with the first color brushstrokes of the still life.

2. The brushstrokes do not cover the background completely to allow the color to "breathe" throughout the entire painting and to be part of the color range chosen. The treatment is very light, so the overall effect can be achieved without defining the forms too much.

COMPOSITION WITH WARM COLORS

The painting developed on these pages has been done completely with a very warm range made up exclusively of reds and yellow ochres (plus some neutral gray to reduce the chromatic "temperature"). Furthermore, the painting is executed on a piece of cardboard that was previously painted red (red iron oxide), which highlights the colorist tendency of the sketch even more. This proves that even among warm colors there are some that are warmer than others. The more saturated colors are warmer while the cooler ones have either more white or black (or both). Otherwise the color harmony is very simple since it includes very few colors and approaches the composition in a generic and somewhat abstract manner.

3. The result is more of a color study than a complete painting. It can be a trial piece, a study of the possibilities of a warm color range for painting a still life. Work by David Sanmiguel.

3

To strengthen the unity of the color range, many artists use color backgrounds: They paint the canvas, the paper, or the board (see picture) with a color similar to the one that is going to be used in the painting. This way, harmony is guaranteed from the beginning.

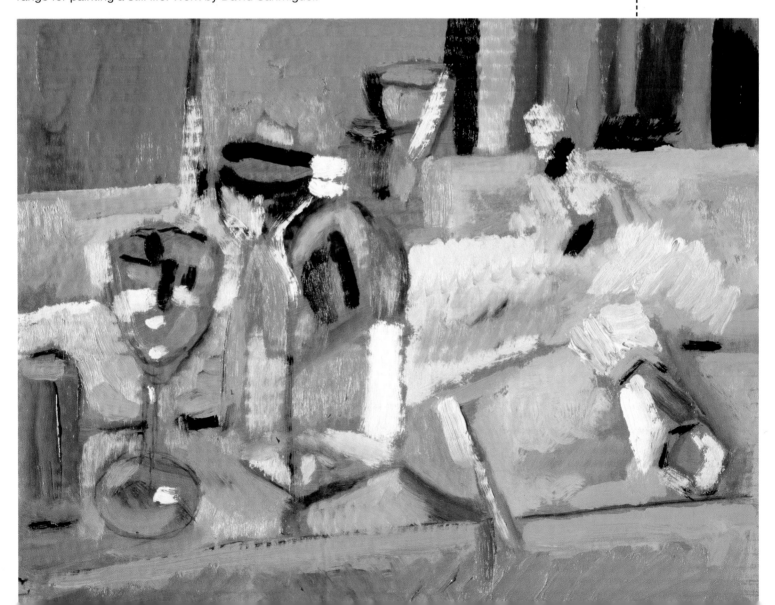

Color Harmony:
Cool Colors

The cool color range includes blues, greens, and all their adjacent colors. These are colors that seem to recede against the warm colors. Working with this color range requires contrasting tones, introducing shades from other ranges (such as yellow details), intensifying, harmonizing, and softening—all of it with the ultimate goal of overall harmony within the piece. The latter is achieved when the paint has reached the point where all the colors support and enhance each other, creating a work without dissonance or monotony, what is known as a pleasing scheme, which like music, has many notes but a single sound, a single harmony. The harmony of this piece is basically cool: Greens and blues dominate this study inspired by Gabriele Münter. The color effect and the luminosity evoke the mountain air, and they support the style used in the painting.

This will be a color study painted with a cool range of colors. The preliminary drawing is very strong and has few details; it is almost a sketch. The lines are very dark blue, almost black. The drawing includes the final color of the man's pants.

COLOR AND BRUSHSTROKE
The cool, almost metallic, tonality of this painting creates vibrancy thanks to a very vigorous approach: The brushstrokes are wide and clearly visible on the various surfaces. This adds energy to a color that is itself luminous. The harmony between blue and green is very lively and is completed by the brief appearance of yellow (the only warm color in the composition). The color has been applied with barely any solvent to enhance the thickness of the brushstroke: the lines made by the bristles on the surface remain visible.

The yellow notes increase the vibrancy of the color and further enhance, through contrast, the coolness of all the colors in the composition. This piece, painted by Óscar Sanchís, is a loose rendition of a painting by Gabriele Münter (1877-1962).

Bright greens and saturated blues: a simple combination of very cool but vibrant colors. The contrast is as vigorous as the drawing is crude, and the effect is fresh and direct.

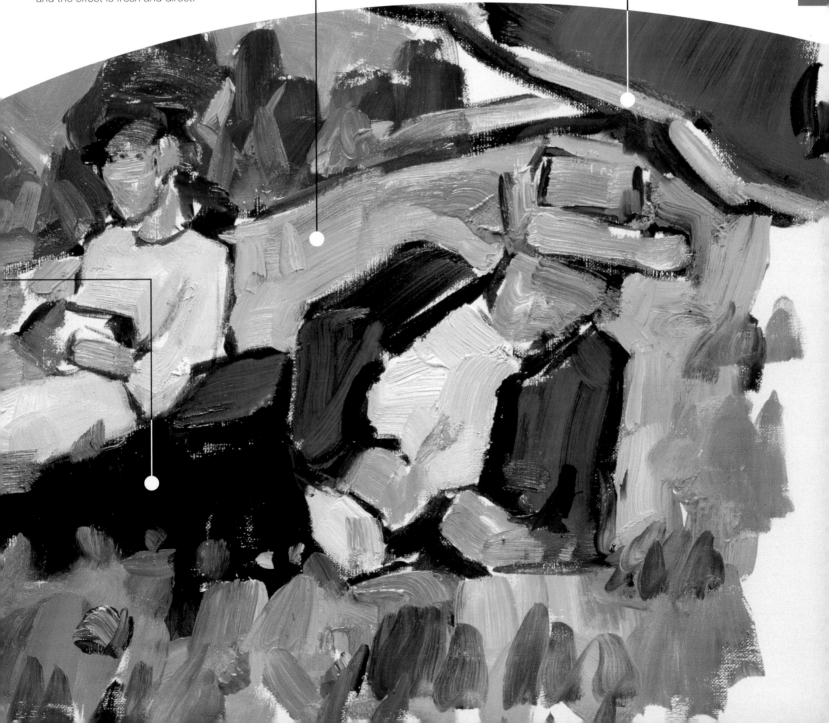

Color Harmony:
Neutral Colors

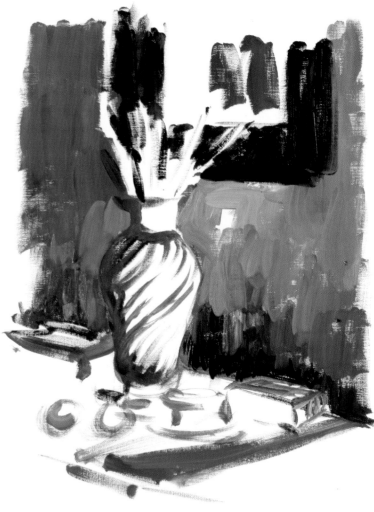

Neutral *grays* are those produced by mixing white and black only: grays without any undertone. The neutral colors are the grays, warm or cool, that have an undertone. They are obtained by mixing white or black into the color (red, blue, green, and so on) or by combining complementary colors and then mixing them with white. These grays with a color undertone, or neutral colors, also can be obtained from earth tones diluted with their complementary colors. Such is the case in this composition's background, where we can see brownish grays and colors with a violet undertone. The central subject, however, has a cool undertone and is more luminous than the rest, which is why it stands out clearly against the background.

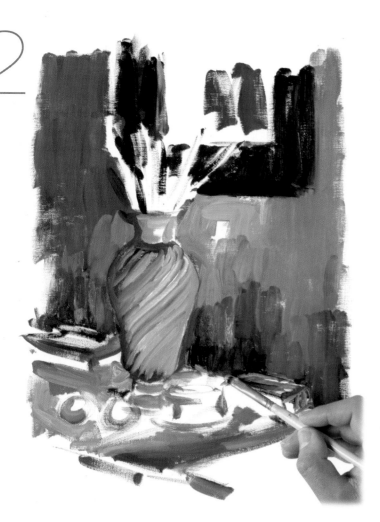

1. The background is a true symphony of neutral colors: ochre-gray, brown gray, dark chestnut, green grays, and others. The powerful black angle of the picture frame enlivens the muted theme.

2. The objects and the cloth in the foreground are painted blue, modeling that color with white and black and giving all the objects the same chromatic undertone. The foreground is strengthened not by the presence of warm colors but because it is a much lighter color than the background.

FLAT COLORS AND BROKEN COLORS

Choosing between the values needed to create volume and dimensionality and the values of the colors is a matter of personal choice, of personality. The choices, however, are not mutually exclusive: An artist may use both techniques according to the subject and the state of mind at that moment, choosing between one and the other with complete freedom as long as he or she does it knowingly, understanding that each one produces different, sometimes even opposing, results.

Still lifes can be treated either way, and the results are equally interesting. In this work the areas of saturated color have been alternated with areas (the background) where neutral colors, the somewhat "heavy" broken colors that create the characteristic somber quality of the painting, are dominant.

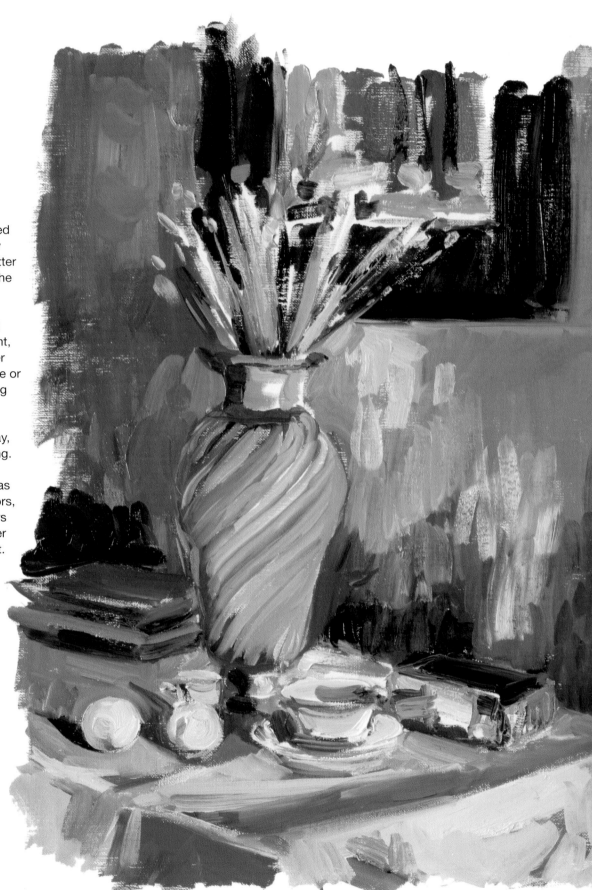

3. Finally, we introduce the only true note of bright color: the green of the vase, which enlivens the entire composition, and defines, through contrast, the richness of the background's neutral colors. This piece, painted by Óscar Sanchís, is another loose rendition of a painting by Gabriele Münter.

Themes
for Oil Pain-
tings

The Figure, Portrait, Still Life,

YVAN MAS. FIGURE READING, 2006.
OIL ON CANVAS

and Landscape.
On the previous
pages we developed a variety

of subjects from very diverse points of view. They were subjects chosen expressly to make a point about something. In the following pages the themes will be studied from a more general vantage point, emphasizing the overall interpretation and spirit of the piece, without losing sight, of course, of any contribution that the work may make in terms of technique. Figures, nudes, portraits, interiors and exteriors, still lifes, landscapes, and even abstract painting will be represented. All of them form part of the art of oil painting.

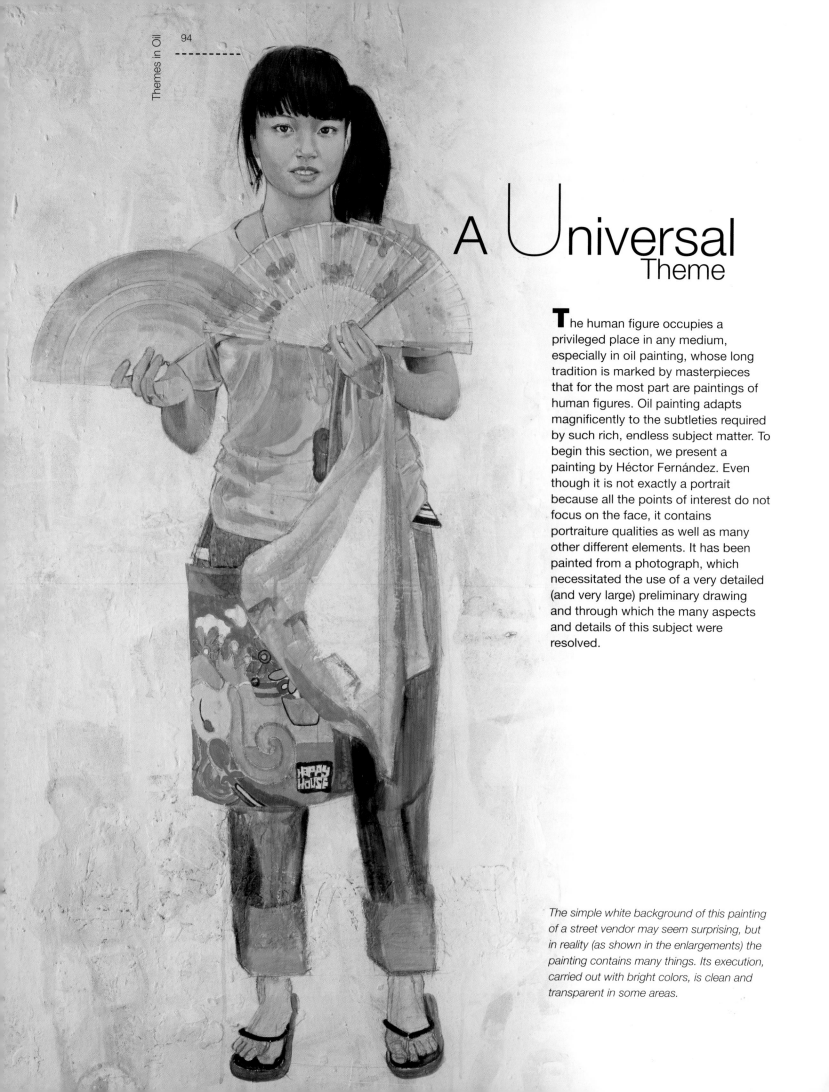

A Universal
Theme

The human figure occupies a privileged place in any medium, especially in oil painting, whose long tradition is marked by masterpieces that for the most part are paintings of human figures. Oil painting adapts magnificently to the subtleties required by such rich, endless subject matter. To begin this section, we present a painting by Héctor Fernández. Even though it is not exactly a portrait because all the points of interest do not focus on the face, it contains portraiture qualities as well as many other different elements. It has been painted from a photograph, which necessitated the use of a very detailed (and very large) preliminary drawing and through which the many aspects and details of this subject were resolved.

The simple white background of this painting of a street vendor may seem surprising, but in reality (as shown in the enlargements) the painting contains many things. Its execution, carried out with bright colors, is clean and transparent in some areas.

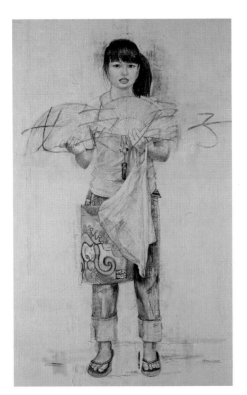

This charcoal drawing by Héctor Fernández is a meticulous preparation for the painting studied here. All the details have been faithfully developed in it.

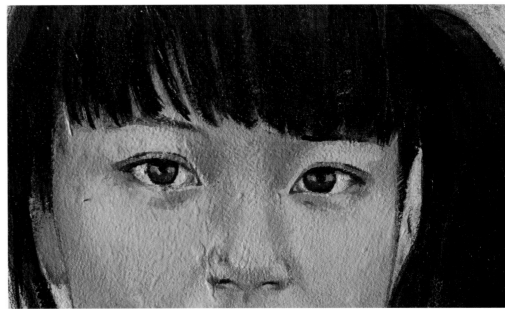

The features have been executed very carefully, using diluted colors and adding a small amount of oil to increase their fluidity and to make them blend easily with other colors.

THE FIGURE AND THE BACKGROUND

It is surprising to see that the figure in this painting is completely silhouetted against a white background, commanding the total attention of the viewer. The background in reality contains many suggestive elements because the white has been repainted over another painting and allows some of the details from the previous painting to show through: a busy street full of figures. This adds somewhat of a subliminal interest to the painting because its subject matter is a street vendor: The "ghosts" that can be perceived are pedestrians, and their understated presence provides an interesting thematic suggestion. With respect to the technical solutions, they can be studied in the comments that accompany the painting's details.

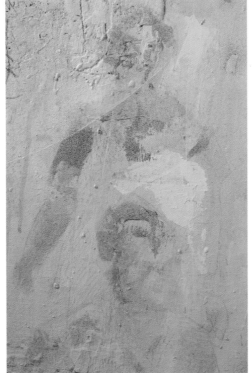

The previous painting comes through the background's layer of white paint. Fortunately, the figures from the previous painting fit this one in terms of the theme. Additionally, the figures that can be made out enhance and add interest to the neutral background.

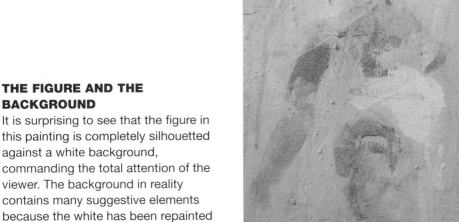

The artist used the girl's bag as an excuse to create an area in which the colors maintain their integrity and are painted without any chiaroscuro treatment. This, combined with the thick lines, produces a result that resembles a tapestry.

Figure in
an Interior

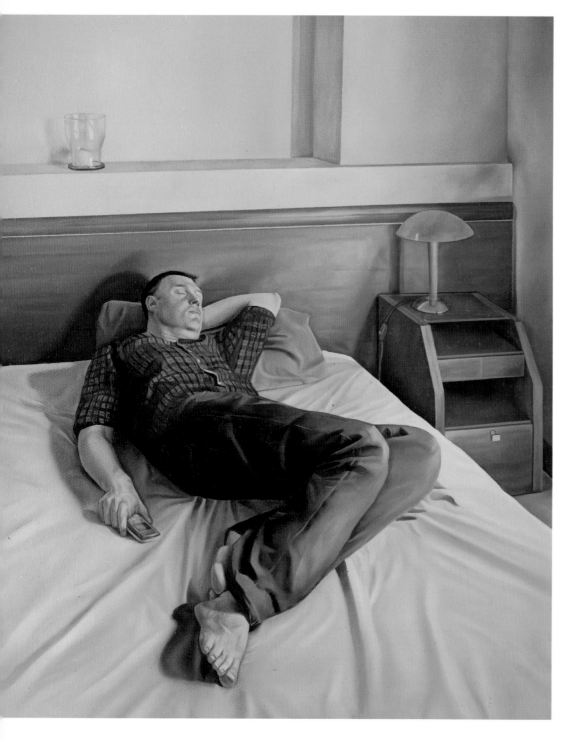

Somewhat closer to the original than the previous example, this painting by Alberto Gutiérrez is a magnificent piece of realism that allows us to scrutinize the refined technique used for its execution. This time the model posed for the painter, who was able to carry out a thorough study of the features and the incidence of light over each one of them. It is interesting to see the extremely clean execution, without any brush marks: The artist worked with a solvent to which he added oil to lighten the brushstroke and to achieve color blends that look perfectly continuous.

The originality of the subject matter does not minimize the very realistic and thorough execution, which are precise and delicate at the same time. The piece has been painted with very smooth colors, blends and shades that closely follow the contours of the subject. Only a few colors have been developed with great richness.

The care taken with the smallest details is evident in this meticulous representation of the transparency of this glass and its complex shadows.

COOL AND WARM COLORS

The color scheme of the painting is divided between warm and cool colors: warm for the furniture and the wall and cool for the sheets and the model's clothing. Therefore, the parts of the figure's skin that are exposed (warm areas) stand out vividly against a cool surrounding. The reds, earth tones, and siennas are the dominant colors, while the turquoise blue of the sheets comes through as a defining note. The overall treatment is a chiaroscuro softened by the multiple shadows and reflections.

All the areas have been finished with the same attention to detail, controlling the light, the shaded areas, and the cast shadows with great precision.

The head is a splendid portrait treated with great attention to its mass and form. Without forcing chiaroscuro, subtle blending of the brushstrokes achieve a unified and smooth surface.

This is a small still life included in the painting. In it we find again all the virtues contained in the details of the figure: precision, refinement, and color restraint.

The Nude:
Study of the Human Form

This nude by Héctor Fernández shows a very free approach that does not shy away from the perfect anatomical execution. The color is applied quite liberally, always within the confines of a very orthodox drawing.

No matter how cold and distant the style of an artist may be, the intention that moves him or her is seen in more than just the subject matter of the work. Whether it is a very ambitious piece or a very humble study or sketch, there is always an artistic intention, aesthetics that go beyond pure representation or a technically correct copy of the subject in question. This is especially true in figure painting, and even more so when we deal with nudes. The "object," which is a human body, provides infinitely richer suggestions than any other pictorial subject matter. This fact affects the work of the painter, in such a way that he or she will not only wish to represent the way the body looks on the outside, but also to express its inner human side. This tendency to go beyond the objective information—this "vision" of the form—is the most elemental of the artistic intentions of the painter.

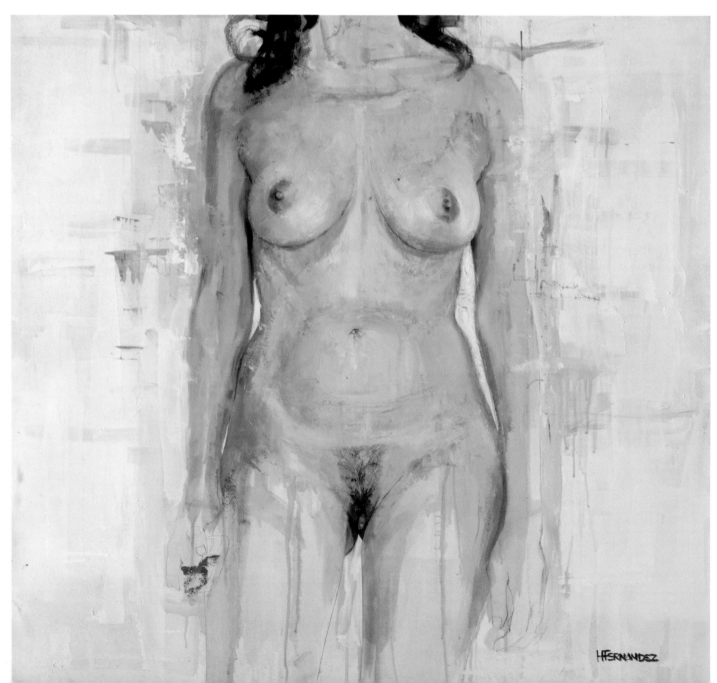

HFernandez

THE INTERPRETATION

Interpretation refers to the personal way in which each artist develops his or her own artistic intention. Every interpretation has a strong personal component, even the most realistic and apparently objective one. In addition, interpretation is essential in conveying authentic interest to the work and for awakening in the viewer the curiosity and the appreciation for the painting. Interpreting means emphasizing those aspects of the model that have most vividly caught the attention of the artist through its color, line, composition, and such. Next, we are going to study these elements in detail.

The fact that the head is not shown in these nudes corresponds to the intention of form. The painter does not want to interject any psychological factors between the anatomy and his or her artistic intention. This is very close to the classic intention of formal perfection.

In the hair, the painter has been able to relax the brush and to let it move freely, accumulating paint and leaving visible marks of its movement.

At close range, the flesh shows great richness of color that cannot be appreciated from a distance. Here, we can see green tones hidden under the skin's pinks and siennas.

In this nude by Alberto Gutiérrez, what stands out is the attention he has given to the play of light and shadow and the reflections that add nuance to the anatomy creating a very pleasant three-dimensional feeling.

This male nude isolates the torso, showing dark colors and perfect anatomic articulation.

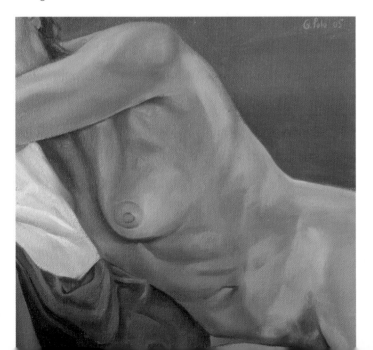

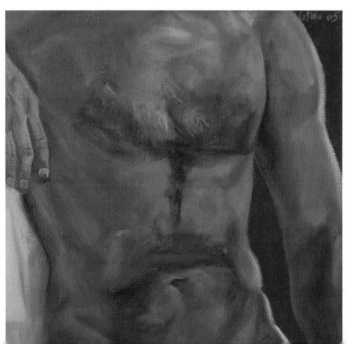

The Realistic Interpretation
of Flesh Tones

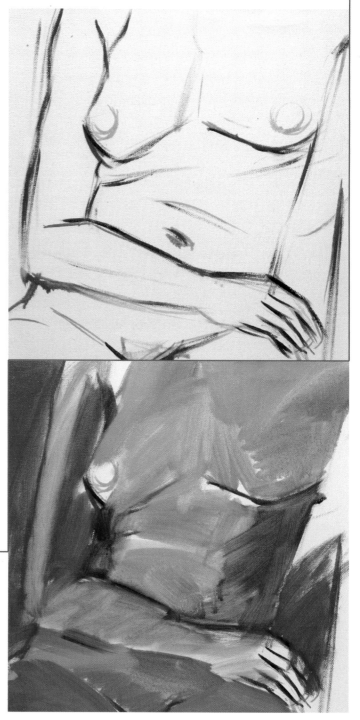

Talking about realistic interpretation is always a relative matter, because realism in painting is a changing subject; however, it can be said that the realistic interpretation of the female nude is one possibility among many others. A possibility that usually embodies an artistic purpose that aims at searching the truth of a human body, without any stylization or embellishment. Here, a female torso is represented in a purely realistic style that accurately reproduces of the colors of the flesh, which can be found in the warm range of reds and earth tones, highlighted by a very bright red background.

THE PICTORIAL PROCESS

With this sequence we would like to reconstruct a much more elaborate work by the same author (also reproduced here) that was painted from life. The same pictorial guidelines have been followed in both cases, although in the most elaborate work, the painter has developed the shading in a more deliberate manner. The preliminary drawing is very simple so as to not interfere with the colors, which are applied to the canvas with wide, generous strokes. The artist is always in search of contrasts between the values that little by little become more defined and clear to make the volume and the three-dimensionality of the anatomy more concrete.

1. The drawing should be simple and clear to provide a reliable guideline without getting into details and colors.

2. A quick overall application of color establishes the different values with a mixture of ochre with a small amount of sienna (in addition to a pink that is somewhat soft).

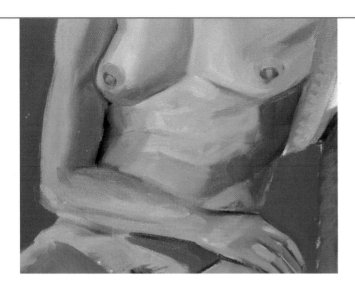

3

No other medium renders the type of finish that is possible with oil paints. From an elaborate painting, one can go into the most detailed of approaches maintaining a complete coherence of form, color, and modeling.

3. The artist, Alberto Gutiérrez, has arrived at this stage by unifying the previous areas of color with intermediate tones that give continuity to the anatomical forms. This is only a sketch of the finished work that is shown here below.

4

4. The nude at its most detailed stage. The progressive enrichment of the flesh tones has required the inclusion of small nuances of very light green and blue in the lighter areas of the anatomy. Work by Alberto Gutiérrez.

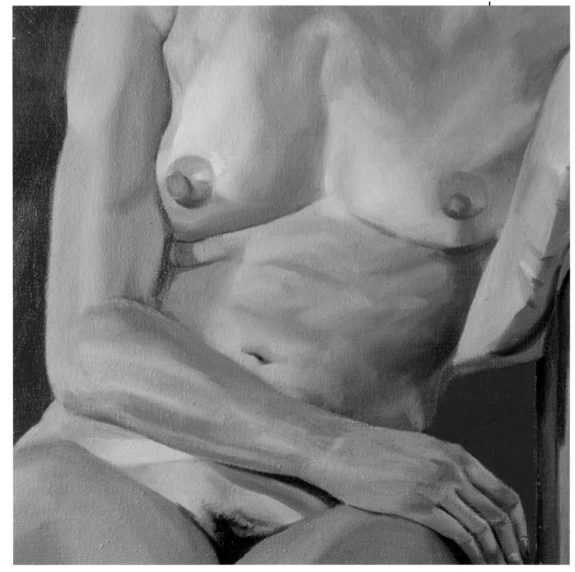

Still Lifes
in Color

Two of the still life examples with oils illustrated in these pages are painted using a wax medium introduced earlier in the book. This medium has made it possible to achieve a very creamy and somewhat translucent result that can only be seen in photographs (the particular glossiness provided by wax cannot be obtained without this altering of the paint). Saturated color is further enhanced by the wax medium, giving the entire surface of the canvas a sensual appearance. However, these still lifes are also interesting as examples of the efficiency of oil paint in this traditional theme, which calls for compact and well-organized compositions. In these paintings the positions of the objects follow a compositional logic based on color with clean contrasts between warm and cool colors: In almost every instance a warm object is juxtaposed by one painted with cool colors.

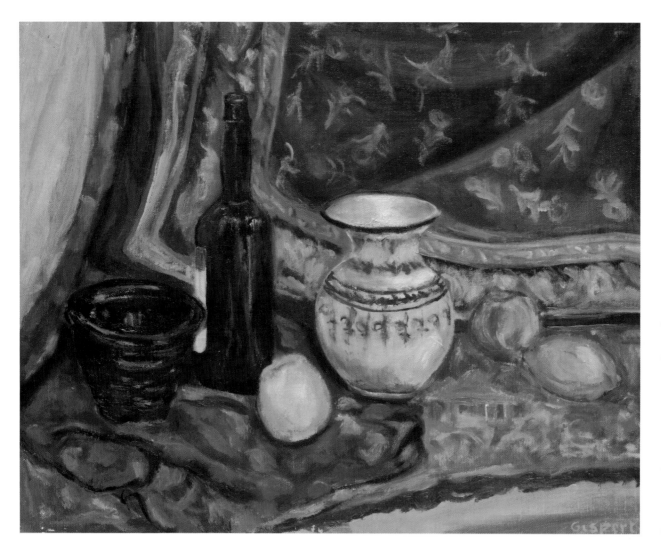

A style based on color works particularly well with still lifes no matter how accurately the model is reproduced. The vivid contrast between the blue greens and vermilion red enlivens the entire composition. Work by Joan Gispert.

When color, brushstrokes, and paint are the dominant elements, line must be necessarily relegated to a lesser importance. This color study shows an exclusively colorist treatment. Work by David Sanmiguel.

It is important not to be carried away by the model; instead the artist should have command over it. When the subject presents a detail that lacks pictorial interest, it should be ignored. One way to achieve this is to find a very colorful still life to begin with: This solves a big part of the problem, but the rest is up to the artist. Work by David Sanmiguel.

PAINT GUIDED BY COLOR

If the artist works the still life guided by color, we can guarantee that the painting will not fall in nondescript realism: Colors always "live" on the surface of the canvas. To give the objects mass and add a feeling of depth to the still life, shadows should be colors and modeling should also be based on color. Therefore, the artist has to ignore the dark colors that lack expression and that can be seen in real nature and translate them into areas of color, making up tones that convey a feeling of reality. This is true interpretive work.

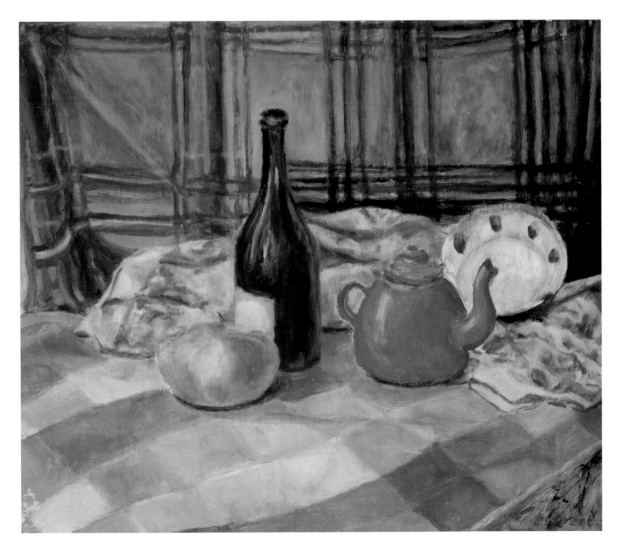

In this still life by Joan Gispert we also find contrast between complementary colors (red and blue green). In this case, it includes warm colors: yellows, oranges, siennas, and such. The power of contrast enlivens the entire piece.

Nature and Urban
Landscapes

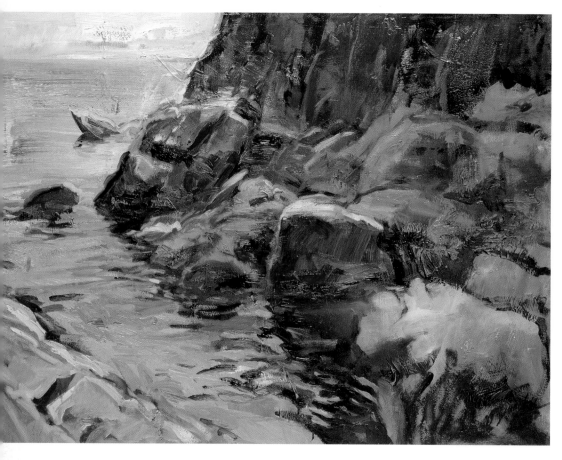

Light is always the protagonist in landscapes, especially if the landscape is painted on location. However, whether on location or in a studio, the painter must always face the problem of natural light in an outdoor scene, which is very different from working with objects or figures subject to a light that is fixed and constant.

Therefore, there is no point in practicing a systematic approach to each object in chiaroscuro because the reflections of some surfaces upon others, and the shadows cast by them, create a luminous atmosphere that is much more diffuse and encompassing. The scene must be unified in the use of light and color to be interpreted as "natural," that is, belonging to a time of day and to a season of the year.

Seascapes are a variation of landscapes and require a rich treatment to keep from looking sketchy. These rocks near the shore painted by Óscar Sanchís rely on heavy paint to illustrate the dramatic chiaroscuro effects.

An urban scene must have certain human vitality, especially if it contains figures moving about (for example this work by Óscar Sanchís); this vitality is the ultimate appeal of any scene found in modern cities.

Here is a direct and spontaneous treatment, very rich in paint and sparse in terms of line. A simple and loose representation of the landscape based on the freedom of the brushstroke charged with paint. Work by Joan Gispert.

LANDSCAPE THEMES

Every part of nature provides subject matter worth being painted. The artist has to be able "to see" the painting in his mind before executing it guided by those first impressions.

This first impression must be the trigger and the guide for the work because light changes constantly and what was bright and luminous before can turn dark quickly. The initial contrast must also be the definitive one, with all its precise nuances. Only this way will the piece maintain the freshness of a natural scene.

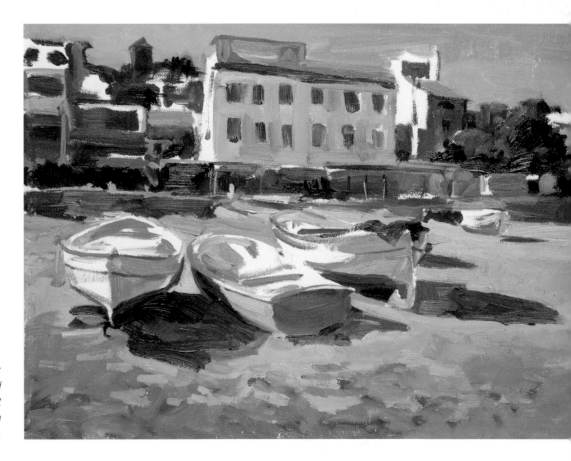

A seascape with a reversed point of view: from the sea toward the land. The boats and white houses are charming elements that today, and always, have caught the attention of the oil painter. Work by Óscar Sanchís.

In these pages we analyze an interesting urban landscape, which consists of a subject very dear to Impressionist painters: a big train station covered with a monumental metal structure. These large engineered structures are not used much anymore, a fact that gives them greater interest due more to sentimental reasons rather than practical ones. The artist, Álex Pascual, saw a magnificent model in this structure dominated by the intricate web of iron beams and arches that unequivocally evoke the solemnity of the great architectural ribs of gothic cathedrals. The work includes a cool palette limited almost exclusively to blues and grays. Grays that are almost black highlight the faint and somewhat melancholic luminosity of the grand station.

The contrast between the dark beams and the light sky has been achieved by following the rigorous drawing very closely, going over it with dark brushstrokes and filling up the empty spaces with warm and cool grays in thick paint.

An Urban
Theme

RHYTHMS

Alternating between straight lines and curves, between light and dark, between soft color and saturated color, can cause confusion if it is not well organized and rhythmic. The correct rotation between notes and silences is found in the pleasure that we achieve from rhythm. The more varied the forms the more rhythmic the composition will be, as long as the order is implicit.

This interior painted by Álex Pascual has much in common with the work studied in these pages. The location is different, but the spirit (a mixture of attachment and detachment) is very similar. An example of how different subjects can originate from similar situations.

Here, the contrasts between the beams and the background are very minimal: They are contrasts between cool colors (beams) and warm colors (background) of similar value. The integration of forms and background is very harmonious.

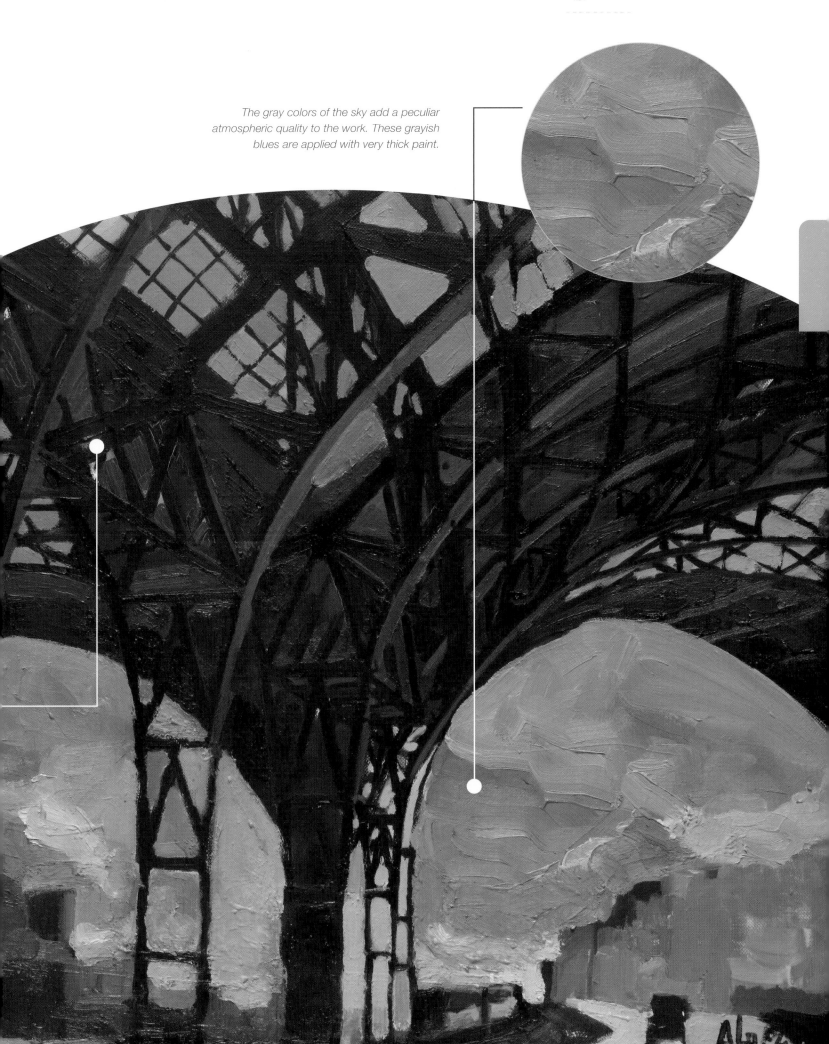

The gray colors of the sky add a peculiar atmospheric quality to the work. These grayish blues are applied with very thick paint.

Abstract
Painting

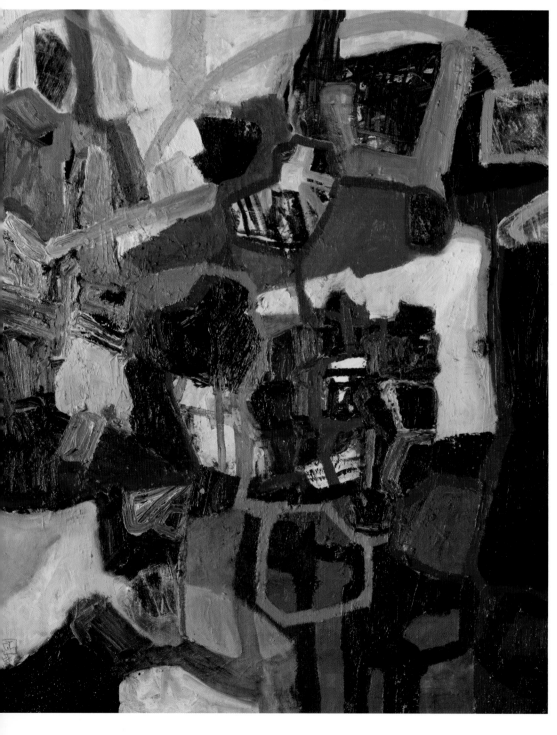

Abstract paintings show us that the painted surface can have a high visual interest even when it does not represent objects or figures. The colors, the brush marks, the lines, the textures, and the ornamentation are enough to enliven the painting and give it vitality. This suggests an interesting idea: that painting techniques do not depend on the subject matter and can be developed independently of it. Sometimes a form is modeled on a base of rough paint that extends beyond the limits of drawing; that roughness creates a tactile impression that the mind instinctively associates with certain real textures. The work studied here presents numerous abstract examples.

This work by Álex Pascual presents a web of very visible lines that emphasizes the division of space that is characteristic of any composition. The emphasis on the lines goes so far as to radically affect the distribution of colors, in much the same way as scaffolding outlines a building's shape, size, and proportions. Color becomes important and can at that point be distributed over the canvas at the painter's fancy.

Spaces and lines interchange: At times the lines suggest structures that the spaces deny. In this game of suggestion and rejection, we encounter one of this painting's attractions.

SPACE AND SURFACE

The method followed in this exercise responds to the color harmony of the canvas, rejecting the effects of chiaroscuro. Although there are several planes of black color, the colors maintain their integrity and are not subject to chiaroscuro gradations. By combining this with the presence of strong compositional lines, the result looks like stained glass or mosaic.

The artist has to invent forms that are representative of objects but that at the same time must be "flat." The overall effect is two-dimensional, but the contrasts between cool and warm colors provide some suggestion of space that makes the representation look more natural. Each color on the canvas is interesting in its own right, independent of the subject represented, and it also conveys spatial distance.

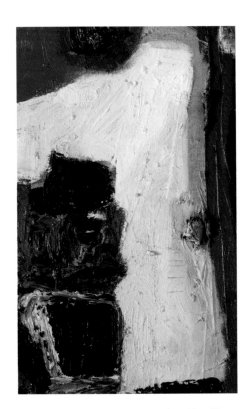

The whites are never completely white. They have shades and glazes that give them depth and add charm.

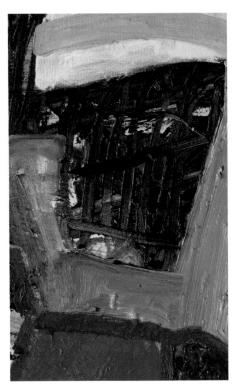

The lines and the areas of color adjust to each other without creating complete dominance of one over the other.

The substance of the material and brushstrokes of saturated color play an important role in the sensual and tactile experience of this piece.

Step
by
Step

"WHAT IS ONE TO THINK OF THOSE FOOLS WHO TELL ONE THAT THE ARTIST IS ALWAYS SUBORDINATE TO NATURE. ART IS IN HARMONY PARALLEL WITH NATURE."
Paul Cézanne (1839-1910)

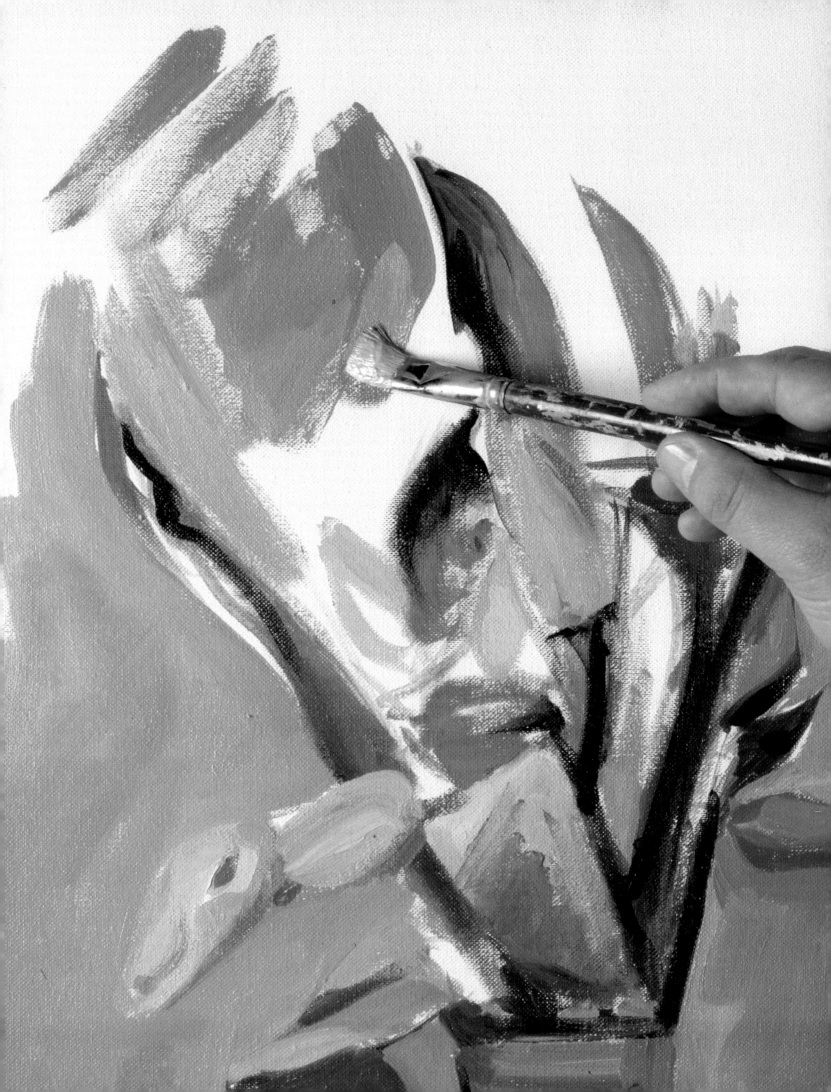

An Urban
Riverscape

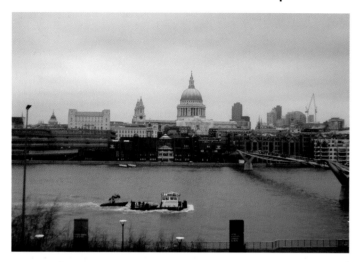

This painting depicts an urban riverscape, which, in terms of size, could almost be classified as a seascape: a large expanse of water that flows horizontally from one side of the canvas to the other, complete with the majestic buildings of a large city. The technique used is based on the combination of colors applied with large brushstrokes that convey the foggy and misty atmosphere of a wintry morning. The layout of forms is almost geometric, and the artist, Yvan Mas, has taken artistic license with the color of some of the elements of the landscape.

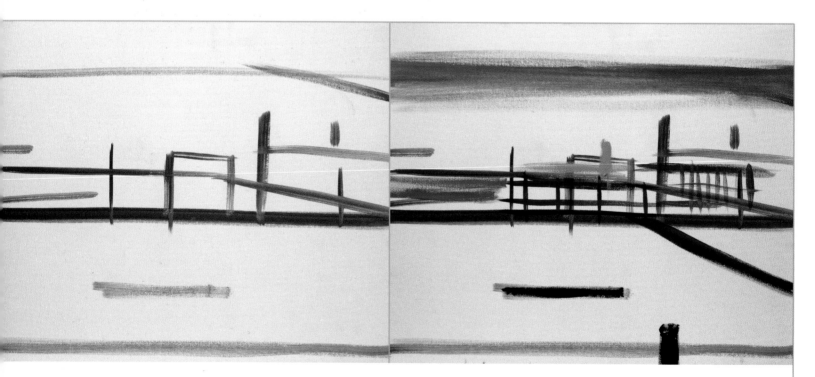

1

1. These sketches, which are completely abstract, are the ones that will hold together the composition of the piece. It is very interesting to study them and to compare them with the more advanced stages of the painting. These simple and rigorous lines establish the height of the horizon, the size and placement of the architectural masses, as well as the elevation of the most significant skyscrapers. The bridge to the right, which completes the composition, forms a very strong diagonal.

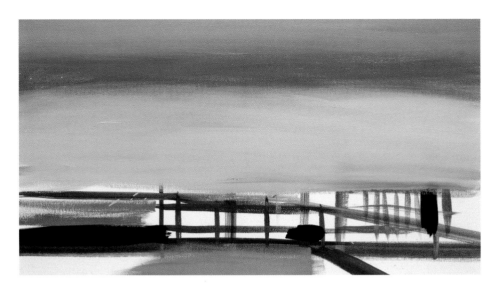

The blending of tones is achieved by applying long brushstrokes from side to side on the canvas. Each brushstroke reduces the contrast between adjacent colors until a smooth and continuous transition has been achieved.

2

2. Almost as if he is defying the rigors of the geometric lines of the composition, the artist covers the sky with a blend of grayish colors that forms two chromatic layers that mimic the atmosphere.

3. The burst of red comes exclusively from the imagination of the artist, who wanted to juxtapose this warm color on the cold fog of the sky to create spatial contrast and definition (the foreground radically contrasted with the background). The solution does not feel jarring at all due to the combination of intermediate colors (such as the waves and some details on the river), which reconcile the two contrasting fields.

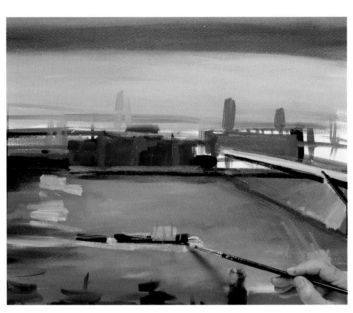

3

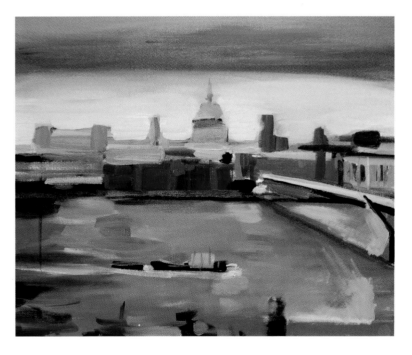

4. This is a very abstract piece since the forms in general have been defined with very large strokes of color. This is especially evident in the way the artist has treated the buildings. With a few strokes of color he has depicted many architectural features. The careful consideration given to the proportion and tonality of those strokes guarantees a pleasing result that is not overly contrived.

THE ARTIST CONCLUDES

Finally, the solution for the sky is to increase the blending between the two large bands of color to reinforce the atmospheric feeling (A). The simple chromatic approach to the architecture rejects chiaroscuro in favor of strong contrasts of color that evoke friezes, levels, and towers (B). The red on the river is suddenly interrupted by the bridge and gives way to a very cold, light violet (C), creating an interesting shading effect that evokes the distance of that point with respect to the elements on the foreground.

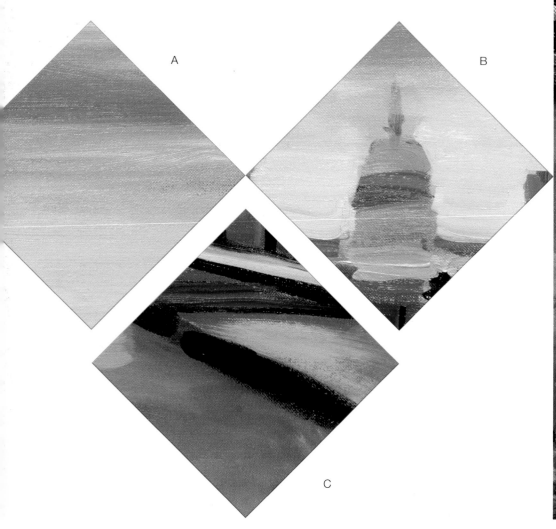

A

B

C

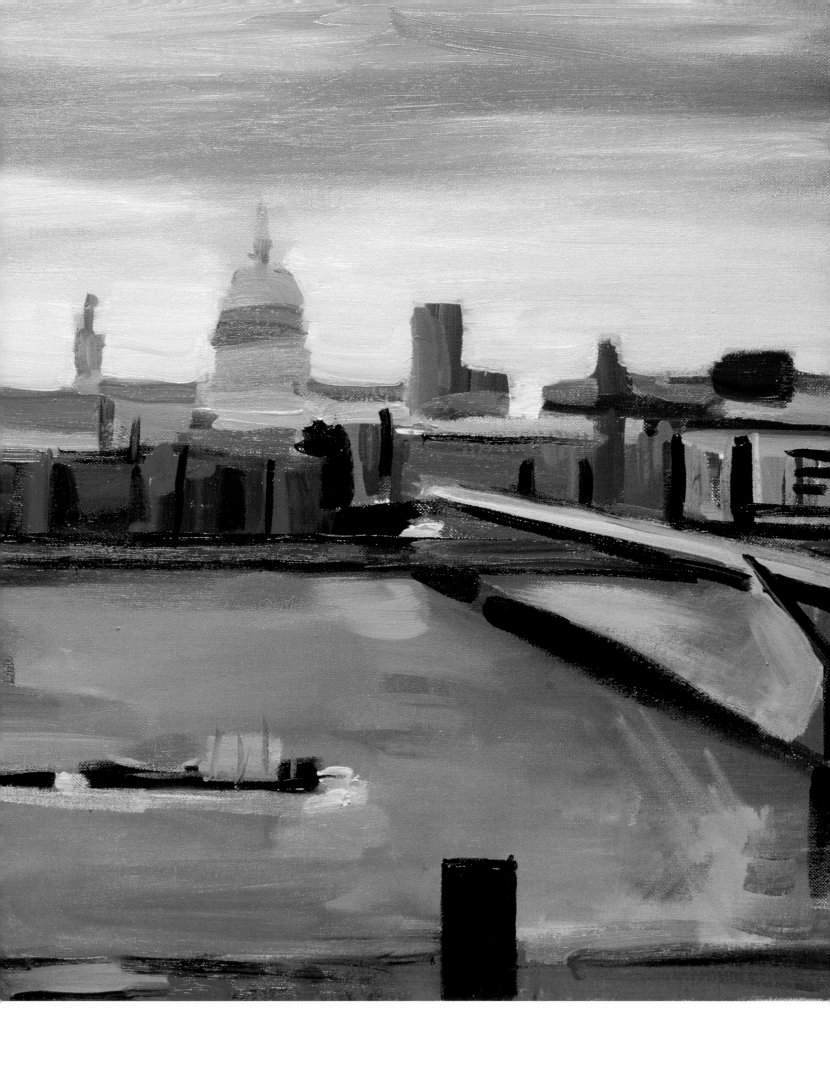

Two Riders
on Horseback

Horses are a classic theme in oil painting. This is a subject that a painter of urban landscapes has very little opportunity to paint. This scene depicts an equine festival in a rural town. Óscar Sanchís paints the scene in a very simple way: with direct colors and with barely any repainting, completing each section of the work one after the other. This approach is feasible only if the preliminary drawing is good.

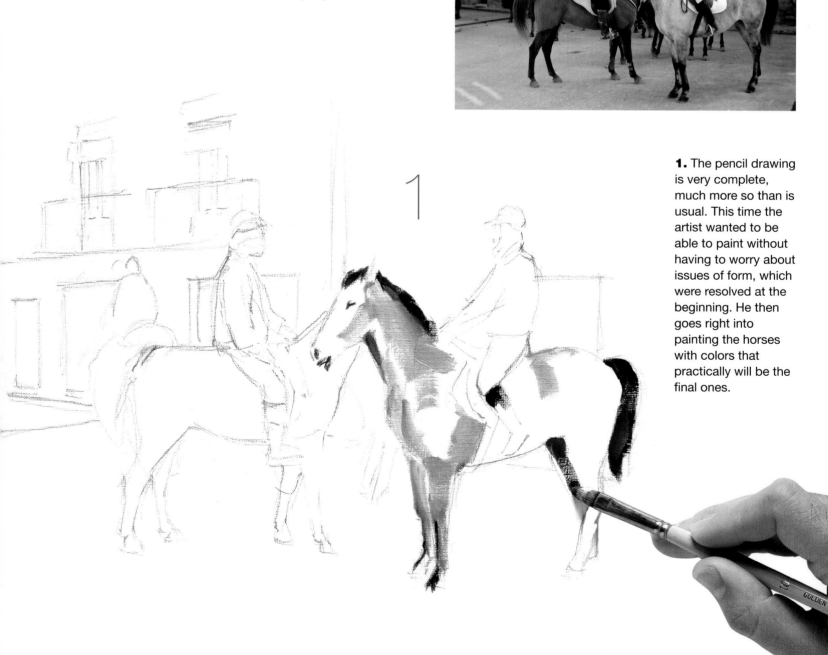

1. The pencil drawing is very complete, much more so than is usual. This time the artist wanted to be able to paint without having to worry about issues of form, which were resolved at the beginning. He then goes right into painting the horses with colors that practically will be the final ones.

In this piece, the drawing has been respected until the end of the process. The colors interact with each other without altering the delicate outlines of every shape in the painting.

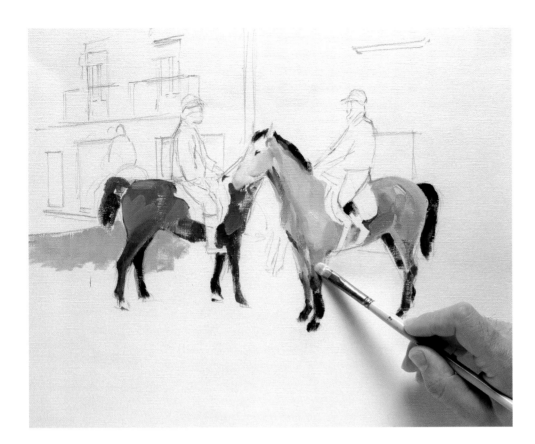

2

3

2. Always respectful of the drawn lines, the artist continues now with the background area, which he paints with a cold, mauve color. The contrast between that cold color and the warmth of the horse's chestnut tone creates a very attractive contrast that produces the illusion of depth as the mauve color (the ground) recedes with respect to the animal.

3. This approach to painting consists of leaving some areas unpainted while others are being completed. In this phase the riders are left silhouetted. Their contours can only be seen outlined against the colors that surround them. This method of painting is very characteristic of artists who work in watercolors or oils.

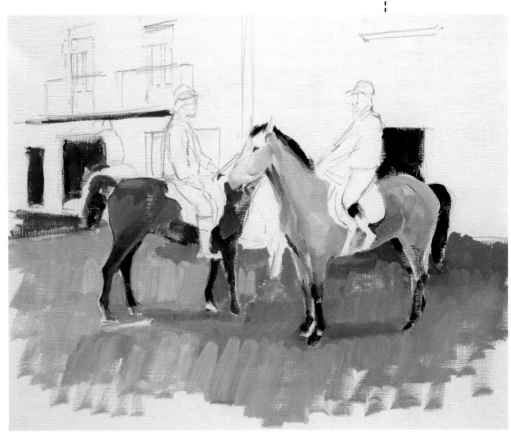

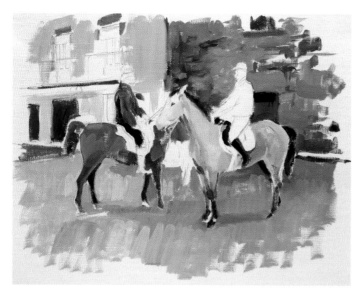

A

4

4. The surface of the canvas has been filling up with colors placed next to each other as if it were a mosaic. The paint is not mixed on the canvas at all; the colors have not even been superimposed; only a few touches have been overlayed, such as the white brushstrokes that lighten the overall tone of the ground in the foreground (where the brushstrokes are more visible).

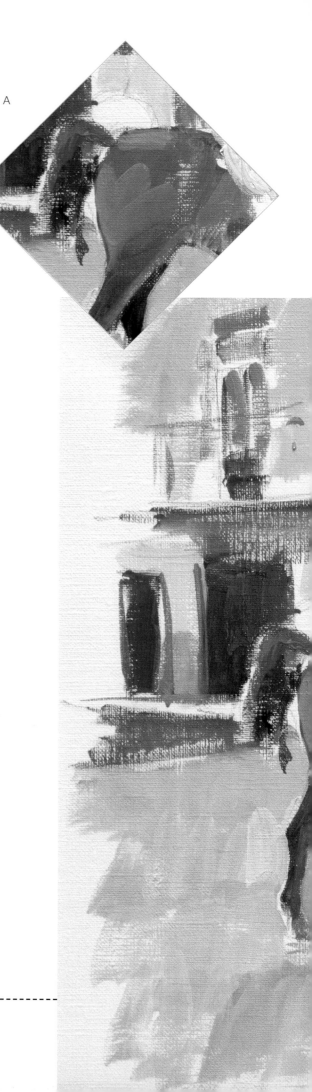

THE ARTIST CONCLUDES

The horse's body has been finished with a burnt sienna color, which was lightened in some areas to create the feeling of depth (A). The details on the figures have been left partially unfinished to avoid disturbing the style of the work; painting the features of the riders in detail would have ruined the overall effect of the piece (B). The coloration of the façade is made of a combination of several neutral tones, cool and warm; to maintain the unity of the painting the artist has used colors that appear in other areas of the painting.

B

C

A Vase with Tulips

The richness of this bouquet of flowers is a very good excuse for making an oil painting. In this case, the elaborate movement of the leaves, the beauty of the flowers, the yellow color, and the interesting diagonal composition created by the subject are pictorial elements that will allow the artist, Yvan Mas, to paint this subject with a completely colorist approach. The texture created with the brush marks will be one of the most interesting aspects of this painting.

1. This project can be classified between a drawing and a painting, between a quick sketch and very detailed representation. The painter used two colors to define the drawing: raw umber (with a greenish undertone) and very diluted carmine. Yellow has been added to these colors.

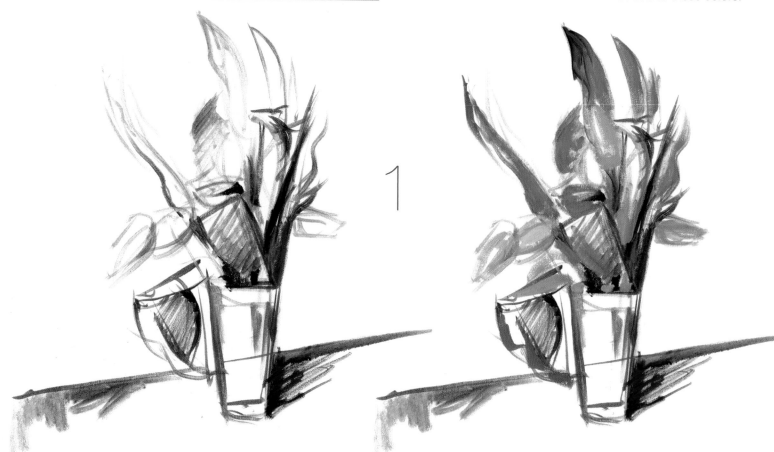

1

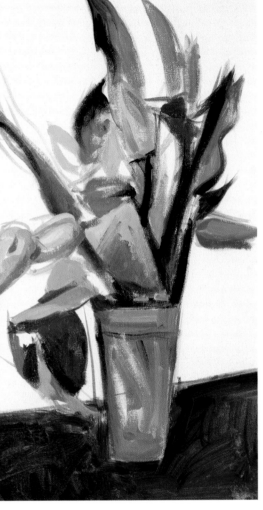

The three initial colors are very diluted so the brush flows over the canvas smoothly, defining details, suggesting shadows, and leaving everything ready to paint.

2

2. Looking at the table, we can see multiple brushstrokes painted across its surface. They are visible thanks to the transparent quality of carmine, which, even when mixed with blue, creates a very attractive effect. The leaves and the flowers have been painted paying more attention to light and shadow; the artist uses orange for the shadows of the flowers and chromium green for the leaves (with touches of white for the lighter areas).

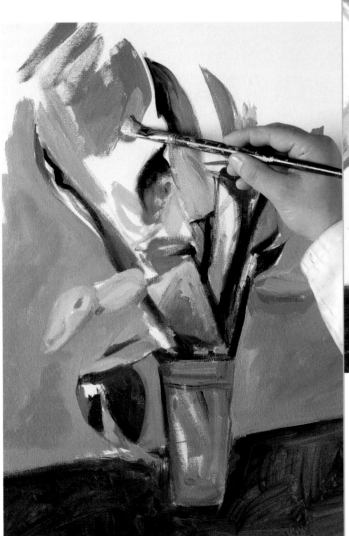

3

3. The background is covered with the same mixture of blue and carmine used for the table; however, in this case, blue is more dominant and the mixture has been lightened with white. It is interesting that the artist has used somewhat different proportions of these three colors; he applies them vigorously to create brushstroke textures and prevent the area of the background from looking like a mass of flat color lacking expressiveness.

4

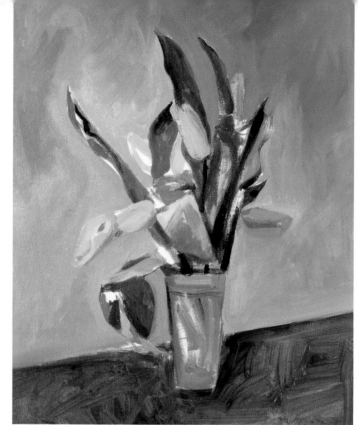

4. The canvas is completely covered. The color harmony is luminous and sweet: the contrast between the cool blues of the wall and the warm reds of the table is the perfect frame for the beautiful coloring of the bouquet. The diagonal of the table suggests perspective, which is sufficient to create a feeling of depth.

A

B

C

THE ARTIST CONCLUDES

The pictorial treatment of the background prevents the color from looking flat. The artist has worked with brushstrokes applied in different directions to create a texture that evokes changes in light (A). The color of the flowers is very saturated cadmium yellow. This lively color has been preserved by reducing the shadows to a minimum, which are orange with sienna undertone. They have been worked just enough to create the volume of the flower (B). Like the background, the tabletop has been covered with brushstrokes that convey rhythm and life to the surface and that go very well with the background of the composition (C).

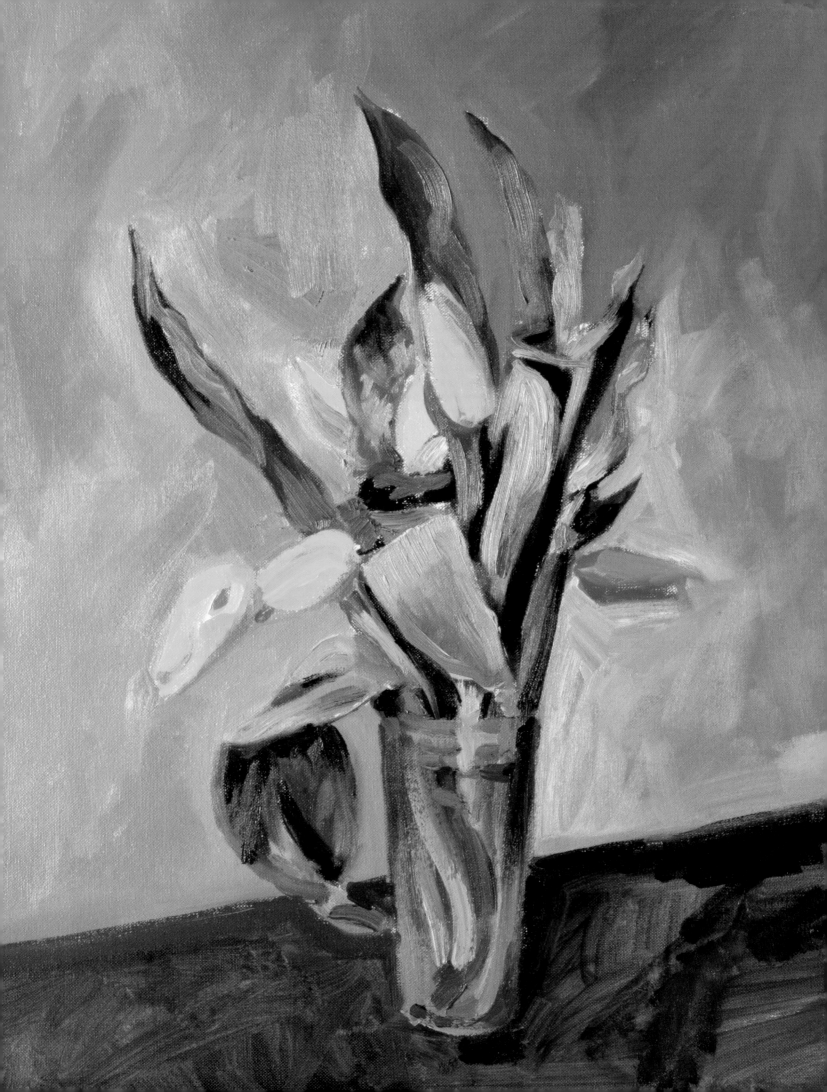

A Landscape
Near the Sea

1

This subject is a combination of a seascape and a landscape. In reality, the sea is simply the background against which the trees are silhouetted, and it has only a chromatic relevance in the composition. Óscar Sanchís worked over a colored canvas to maximize the chromatic appeal of the theme. His method was similar to the Impressionist style: areas of divided color building up the forms through the accumulation of color brushstrokes.

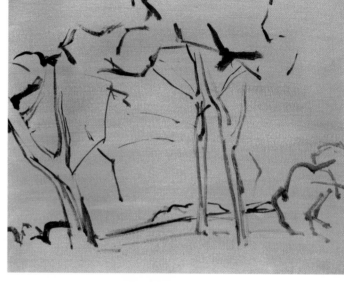

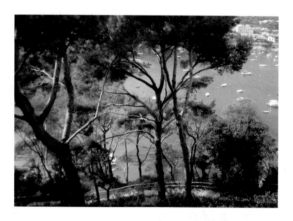

1. The canvas has been painted over with burnt sienna mixed with yellow ochre resulting in this orange background. The paint diluted in mineral spirits was applied with a big brush. The artist let the paint dry for several hours before beginning to paint.

2. Like the Impressionists in their day, here the artist has developed the work from the center outward, extending the color brushstrokes toward the edges. There is no strict method of executing the brushstrokes: They can be irregular in shape and blend with each other, while the color of the background "breathes" through the areas that are still unpainted.

2

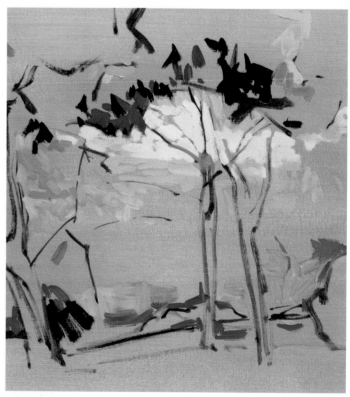

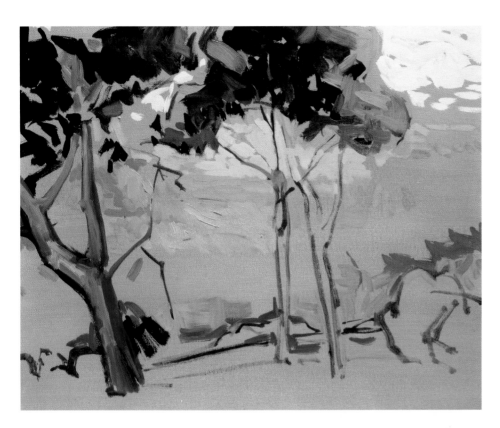

The advantage of a color background is that it unifies the entire composition, and the artist is free to paint without a preliminary drawing.

3

3. The cool and warm colors go hand in hand in the center of the composition as if weaving a multicolor tapestry. This is truly an Impressionist way of interpreting the theme: The same importance is given to each color without regard to whether it forms part of the foreground or the background. The distinct definition of the planes will occur during the last steps of the work.

4. At this point the planes become more clearly defined and the treetops acquire a more coherent shape against the luminous background. The brushstrokes should be increasingly thicker (with less solvent) for the color to stand out against the more diluted paint of the composition's background.

4

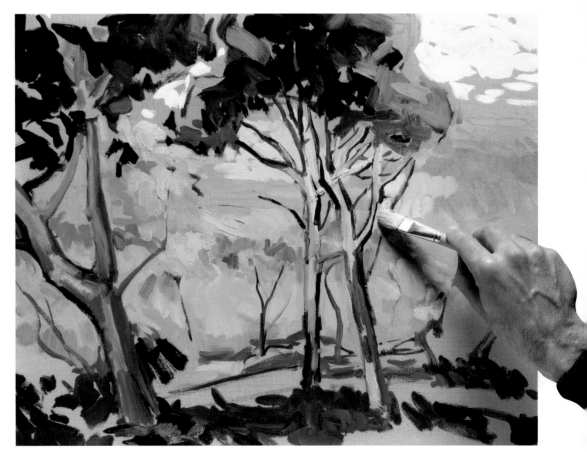

THE ARTIST CONCLUDES

Finally, the entire canvas is covered with paint, and each part of
the subject is precisely located in space, without confusion. The
color has become increasingly more complex and rich in nuances,
as can be seen on the surface of the sea (A). There are also a
great variety of greens, from lemon yellow to emerald green, as
well as orange and intermittent reds (B). To paint the shadows at
the foot of the trees, the artist has added several carmine tones
and dark blues to the overall tonal range to subdue the burst of
warm and vibrant colors (C).

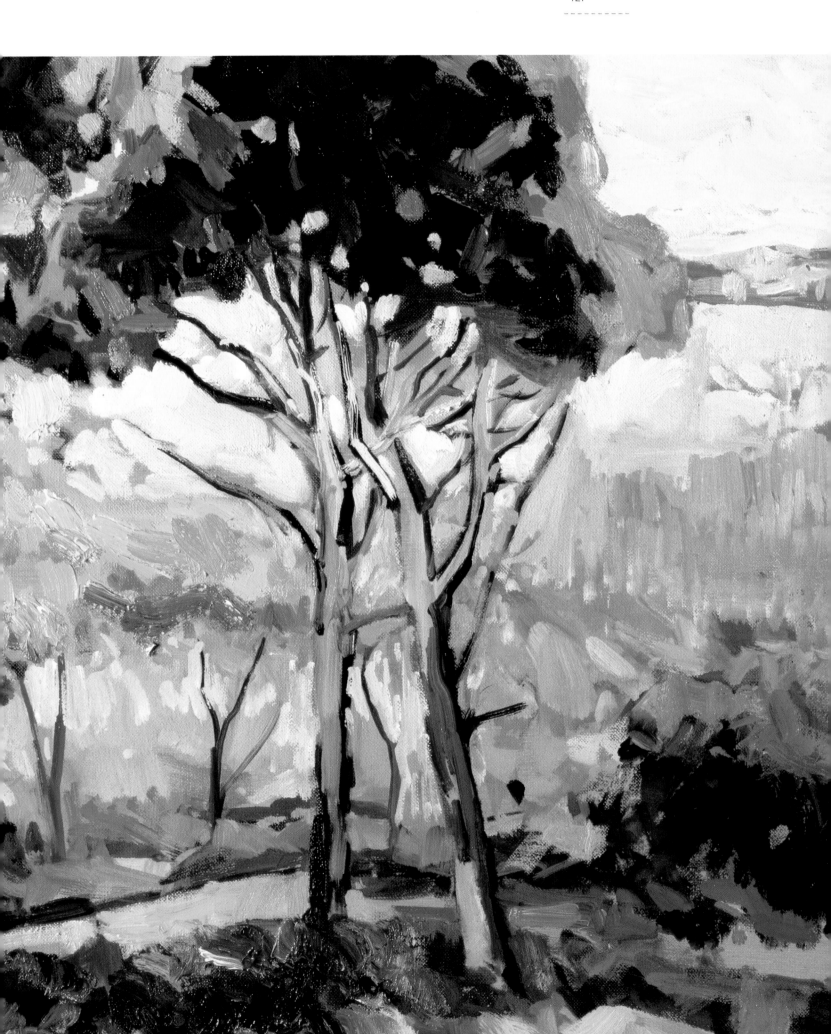

A Still Life with a Limited Color Range

This subject, which looks sparse and simple, is the perfect model for developing an exercise with a very limited color range: ochres and grays. It may seem excessive to restrict the palette so much, but as David Sanmiguel demonstrates, the variety of forms and the free application of the colors can produce an interesting piece full of compositional solutions and rich in spatial perspective.

1

1. Again, a color background is used. In this case it consists of a fairly saturated red oxide color that provides a deep and velvety tone. With this dark background, the artist could paint as easily with black as with white. He chooses both and marks the shapes of some of the objects with saturated black and others with white. The drawing is not a comprehensive representation but a simple layout.

Working with a very reduced, almost monochromatic, range of colors, always guarantees chromatic harmony as long as the contrasts between light and dark values of the same tone are sufficiently varied and vigorous.

2. The ochres are spread in small applications across the tablecloth. This is a deliberate process, and there is no room for the use of large areas of color without regard for the relationship between all the parts of the painting. Texture is created through the application of rhythmic strokes. Here and there, the color of the background is included as one more part of the chromatic range.

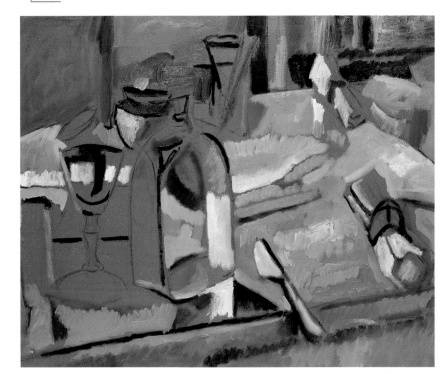

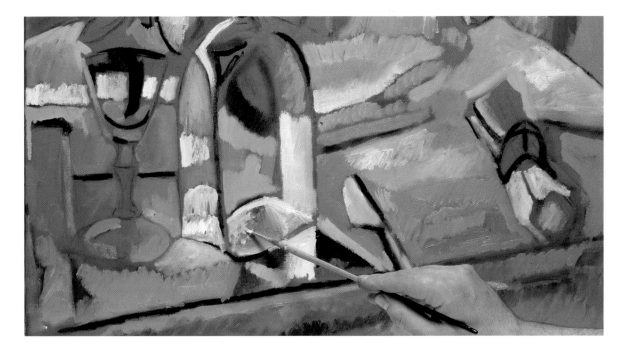

3. With such a warm combination of colors, the grays and blacks become very important for providing respite in the chromatic monotony. Representing the glass of the bottle is a good excuse for introducing a rich range of grays and some blacks. The transparency is liberally interpreted through the inclusion of reflections as well as the distortions created by the glass.

4. Once everything is solidly laid out, the artist can begin to define the space. Grays and blacks are concentrated in the upper corner, which is the most distant area from the viewer. Now, we can appreciate the significant differences between the painting and the original model: The table has been reduced and almost all the distances have been shortened. Overall, the composition has been compressed to achieve a more compact effect.

A

B

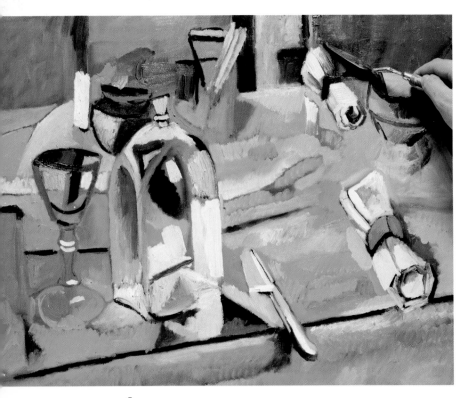

4

THE ARTIST CONCLUDES

Finally, all the surfaces have been defined, even the most ambiguous ones, like the series of reflections on this glass that are resolved with different color planes (A). The colors that create the surface of the glass bottle correspond to the distorted images of the objects behind it (B). The perspective effects in this piece are not very strong, but details such as this handle sticking off the edge of the table provide a feeling of spatial depth and three dimensionality (C). The form of this napkin is achieved through the accumulation of impastos; chiaroscuro effects are reduced to a minimum (D).

C

D

Working with a Painting Knife:
Three Pomegranates

Painting knives occupy their own distinguished place in the oil painting world. Their use is almost considered a genre in its own right, which has many practitioners. Besides the question of how to handle these tools, painting with knives can also trigger certain concerns regarding the results, which may look monotonous and repetitive if the artist executes the technique mechanically. However, with attention and enthusiasm, such as that which Óscar Sanchís devotes to this project, painting knives can provide very interesting possibilities that do justice to the richness and sumptuous creaminess of oils.

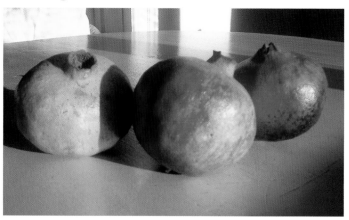

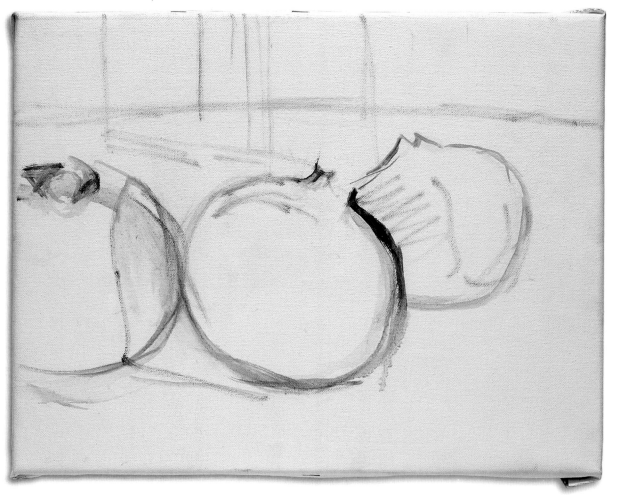

1

1. When working with a painting knife, the base drawing should be very simple because this technique does not have room for details: The painting knife dictates an approach that is broad and dominated by color mass. Details are superfluous. Here, the objects have been drawn with very diluted ultramarine blue.

2

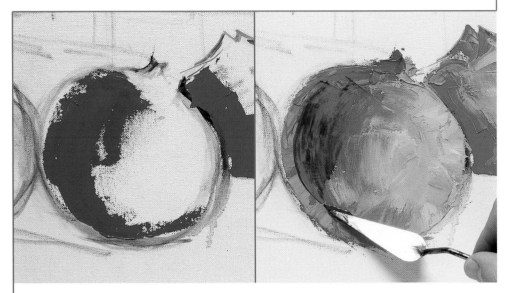

Oil impastos are very vibrant and attractive. Pieces that are created using chiaroscuro and those in which the net contrast of colors (see the illustration) is dominant are improved through the addition of generous impastos.

2. Each application with the knife creates an area of color with irregular edges that is very difficult to predict. The artist mainly addresses the outline of each piece of fruit, leaving the inside of the fruit to chance. The colors (red and cadmium yellow) are mixed directly on the canvas without any mixing on the palette.

3

3. The color of the surface of the table, even though warm as well, is very diluted with white and has touches of blue to make sure that the bright color of the pomegranates stands out in all its intensity. Here, it is important to proceed carefully to avoid smearing the fruit with paint because this would muddy the tones and would be very difficult to correct.

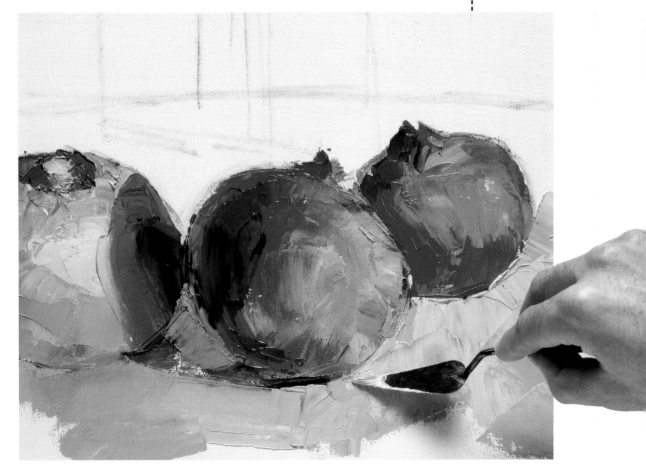

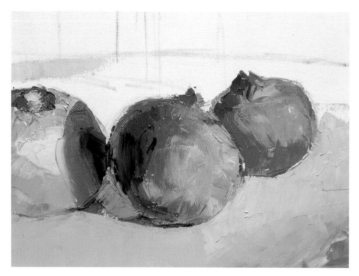

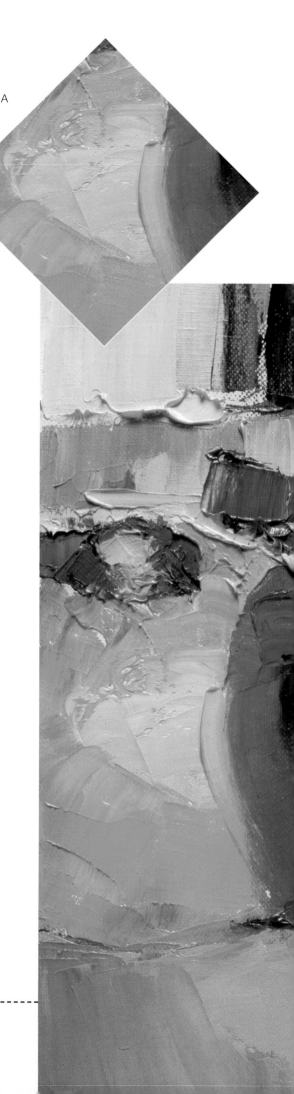

A

4. The painting knife also makes it possible to create large masses of even color, like a plastered or coated surface that has a perfectly uniform finish. This is achieved by going over the paint again and again until the different components of the mixture are completely integrated into the final color mass. The result is a completely homogeneous surface without any shading, which breaks up the beige tonality.

THE ARTIST CONCLUDES

The beauty of the painting knife lies in the apparent spontaneity in which the colors appear next to each other. There is no room for blending and for gradual transitions from light colors to darker ones: The modeling is done through lighter and darker disconnected shading (A). This area shows a considerable accumulation of pigment: The painting knife makes these accumulations possible because there is no need to wait for the color to dry, and the artist is able to layer the new color right over the previous one (B). New gray nuances have been introduced in the foreground to create texture and to break up the extreme monotony of the color created in the intermediate stages of the process (C).

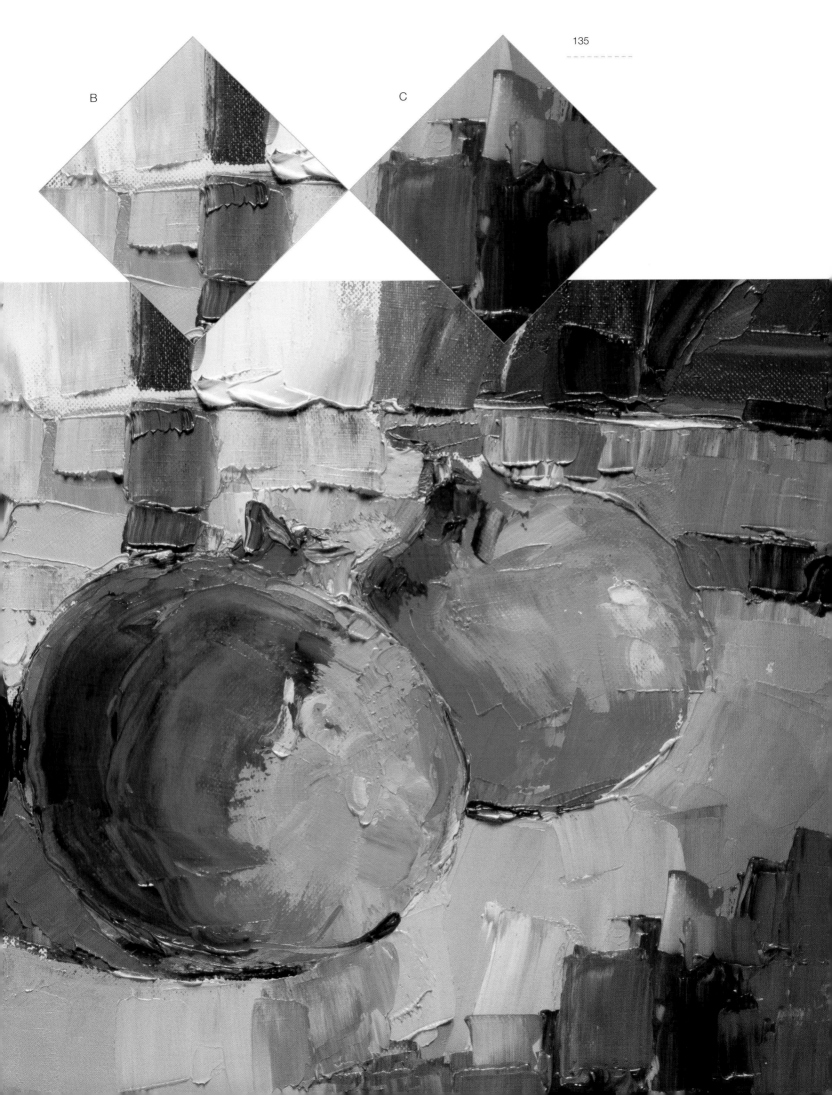

Line and Color
in the Human Figure

There are as many ways of interpreting the human figure as there are artists. However, one can make some distinctions with regard to color, form, drawing, and so forth. For example, it is possible to distinguish figures constructed with line from those interpreted through color. This sequence painted by David Sanmiguel shows the construction process of a figure from the first group: a line drawing that finally ends up being a color interpretation after a very involved process of shading.

1. This very striking drawing has been created with charcoal on canvas and then sealed with a fixative spray. The lines clearly delineate the different parts of the body. However, using a limited repertoire, they also organize the different surfaces of the composition: straight lines for the background and curves for the figure.

1

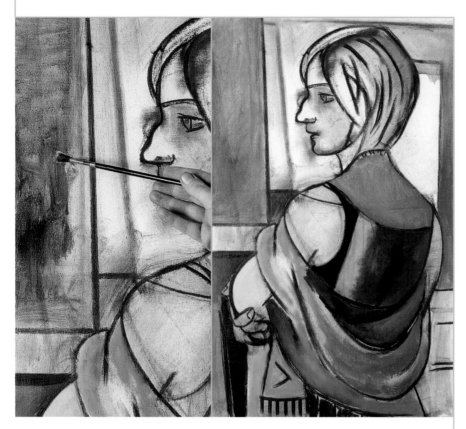

2. After sealing the charcoal with a spray to prevent it from smearing, the artist begins to paint the different planes with color: These are grays lightly tinted with sienna for the figure's skin. The clothing is slightly modeled by adding a little bit of white to the mixture (very little to prevent everything from looking gray).

2

Working from a very vibrant and clearly established scheme is very gratifying because it facilitates and guides the sharp distribution of the areas of color. Later, the drawing can be enhanced or softened with brushstrokes making the color contrasts define the contours.

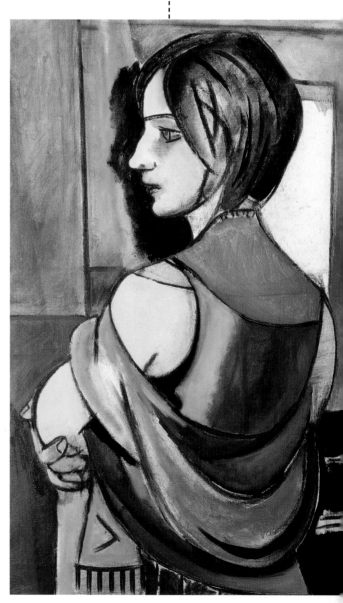

3

3. The entire painting has been covered with the initial grisaille. The illuminated areas of the body stand out against the dark background. From this point on, the idea is to create the colors by translating the grays into lighter and darker tones. This will be achieved through an interpretative range of somewhat cool colors that have nothing to do with the real colors of the model.

A

B

C

4. Here, the colors are already defined: the green of the curtains, the cold gray of the wall, the black of the lower part, and several bluish grays. The background of the composition has been interpreted as well to create a series of simple and well-defined planes that go well with the lines of the figure.

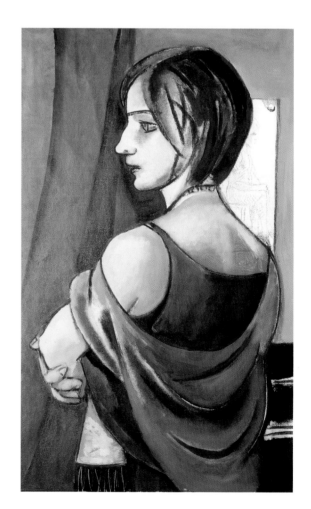

THE ARTIST CONCLUDES

The face of the model has only experienced a few changes since the initial phase of the drawing; just its profile has been defined, and the features have been modeled very softly with warm colors to maintain the integrity of the surroundings (A). In the hair, we can see several undisturbed lines from the charcoal drawing that coexist very successfully with the dark shaded tones, which suggest the flow of the hair (B). The shawl is the most colorful element; bright violets are modeled with blue and small amounts of white, letting the canvas show through in several areas (C).

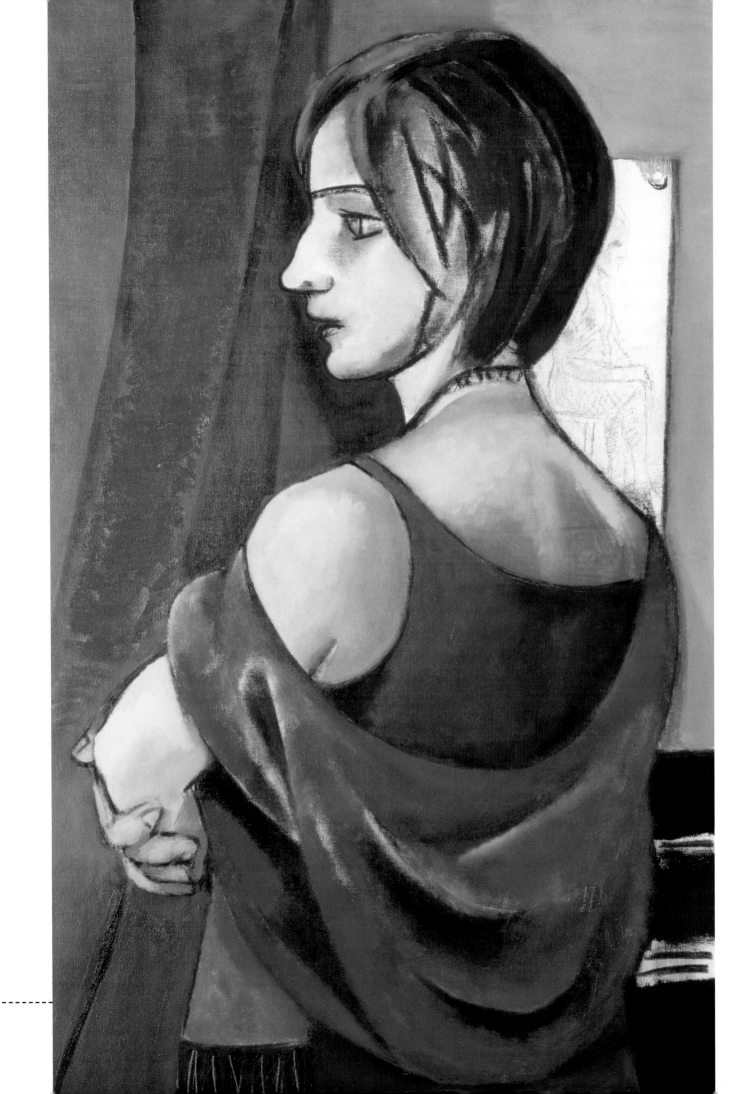

Interpretations of a
Still Life: A Colorist Approach

The subject of the following two exercises is an scene composed of many different images. It consists of a digital collage made from of a variety of pictures of a still life taken from different angles. The subject is an ordinary breakfast table, but its interest resides in the interpretative approach of the preliminary composition. Two paintings are created from this image: one is a colorist interpretation and the other one focuses on rendering the elements of light and space.

Esther Olivé is the artist in charge of the first of the two interpretations of this still life. These are the two preliminary sketches. Since the approach to this painting is based completely on color; the drawing will constitute only the structure for the subsequent work done with paints.

Many modern artists use computers as a medium to support an activity that is basically pictorial. The necessary skills are not overly complex and require only a little bit of experience.

Modern technology for digital reproduction is available to anyone who has a camera and a computer program to manipulate the images. Here, we can see some of the photographs that have contributed to the creation of this project. Point of view, size, and color changes can be worked out and customized on the computer screen.

This is the final drawing that will serve as the starting point for the painting: a very sparse and geometric drawing that divides the surface of the painting into planes or areas that will be painted with very specific colors.

1

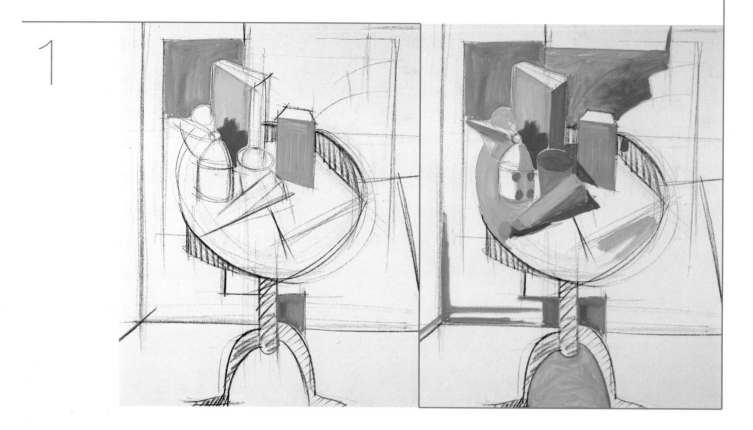

1. The artist begins to paint decisively and without hesitation applying large areas of very warm colors: yellows, oranges, and reds.

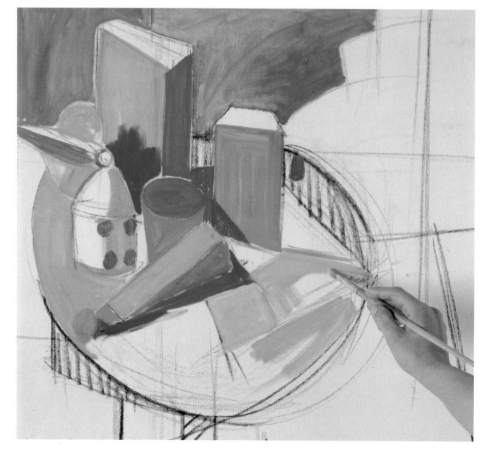

2. In the preliminary drawing, the areas are clearly defined; therefore, it is possible to apply the paint without gradations or color blends. The areas that are designated for the lighter surfaces of the objects are left unpainted.

2

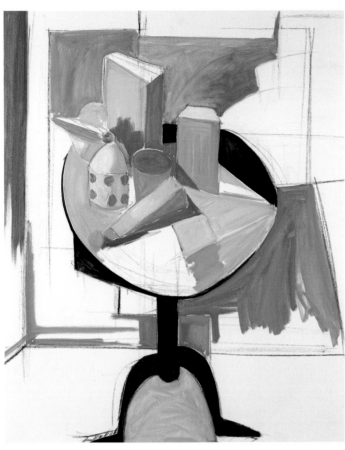

3

The schematic drawing used for laying out the subject gives way to areas of color and to contrasts between pure colors. These contrasts should be between warm and cool colors for the painting to have vitality and visual energy.

4

3. The surfaces in the background are much larger and are reserved for areas of uniform color that are painted with quick and vigorous brushstrokes. Several surfaces have already been painted black, which creates a very attractive contrast against the range of warm colors that dominate in the composition. The plan now is to introduce enough cool colors to suggest spatial depth.

4. All the surfaces have been painted. To the right, there are very large areas of shadow covered with cool grays, needed to compensate the extensive warm tonal range that dominates the center of the composition. In any case, the effect of depth is achieved through perspective lines that show up at the edges of the composition. The cool colors only relax the coloration.

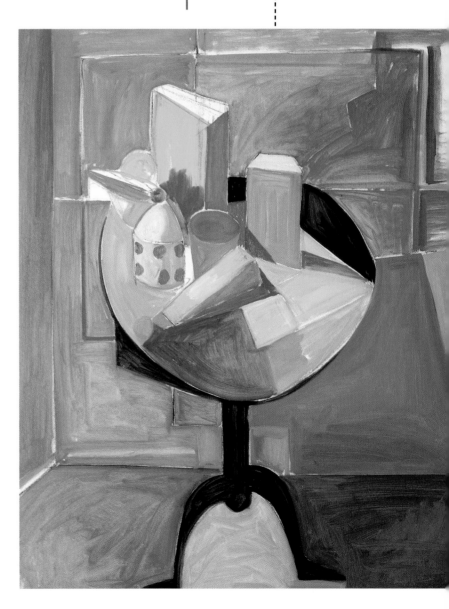

5

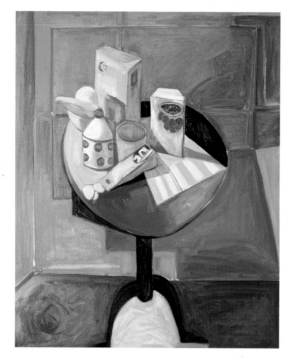

5. The inclusion of the details of the still life (product brands, shapes of the fruit, and the objects) gives a more natural feeling to a composition dominated by extreme colors. These details add coherence that results in the satisfactory resolution of the painting.

THE ARTIST CONCLUDES

Despite the previous stylization of the work through photo collage (which eliminated many incidental aspects of the model), the result is very suggestive in terms of the realism of the objects represented (A). The different planes of the composition are mostly areas of uniform color, but in some cases some modeling can be observed that suggests light and shadow contrasts that are reminiscent of chiaroscuro (B). The background has been treated exclusively with color, and in some areas the constant change of colors has left an interesting textural design (C).

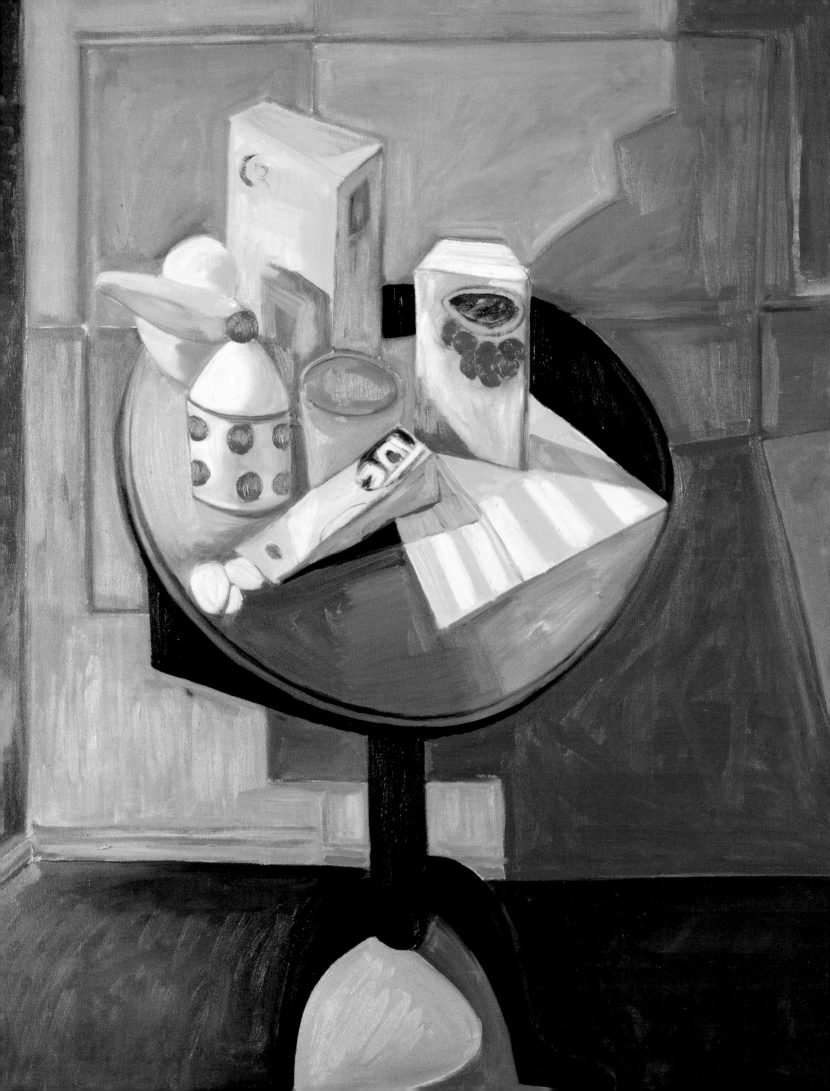

Interpretations of a
Still Life: Chiaroscuro

This is another version of the same subject using a very different approach. This version, painted by David Sanmiguel, is much more about volume and is based more on the material quality of the objects than on the vibrancy of the colors. The range of colors is reduced and somewhat somber to make sure that the shapes conform to the overall tonality. Brown, grays, and dark grays are the basic colors, which is different not only in terms of the overall design but in the specific details of the motif as well. These two pages include the studies, sketches, and preliminary preparations for the paint.

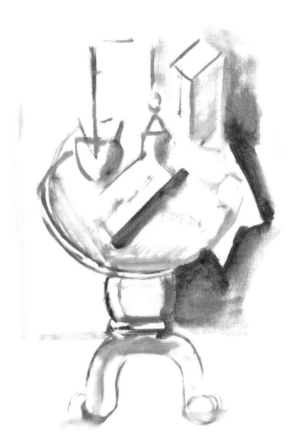

This sketch lays out the general idea for the composition, symmetry, and total flatness, which are the basic factors, the guiding lines, that dominate the work. Otherwise, the warm colors are basically the protagonists of the piece.

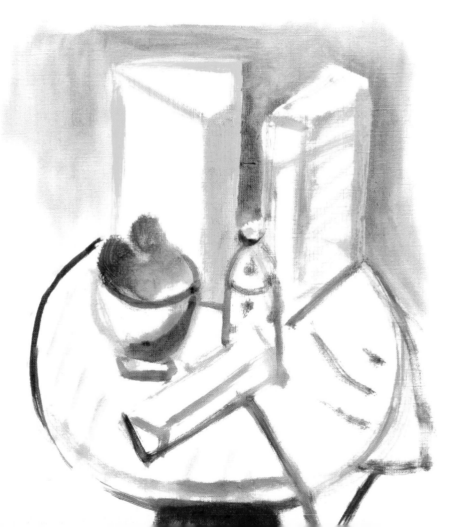

From the outset, the bananas are replaced by green prunes, in response to the overall composition. These prunes are much more pleasing grouped together in the bowl. And also, the piece needed a cool accent among so many warm and deep colors.

Here we can see a suggestion of the chiaroscuro with shadows projected by the still life over the surrounding surfaces. This is an additional pictorial element to be added to the rest as defined by the other sketches.

This is the drawing on the canvas. It is a very elaborate drawing that aims at precisely defining the dimensions of every part of the piece. It is drawn with a pencil because it will not smear as much as charcoal. This helps keep the colors crisp and clean.

This sketch reflects the tonal idea of the motif. The only value contrast (tonal contrast) will be the one created by the white cloth with respect to the other objects.

Some areas of the canvas have been painted with a base color to create a chromatic foundation that instills a certain degree of harmony: ochre for the objects, chestnut brown for the background, and gray for the shadows.

1

2

1. The background color has been of great help for beginning the painting of the objects in the composition. Their colors are very similar to the background tones, so the first approach was to adjust the values in the center of the painting. The lines have been redrawn with burnt sienna, and now the real outlines of the objects that form this part of the still life can be seen more clearly.

2. Here the particular colors of the background, those of the fruit and the boxes, have been defined. The entire painting becomes more defined, especially the table, whose legs have been exaggerated to make them more descriptive.

3

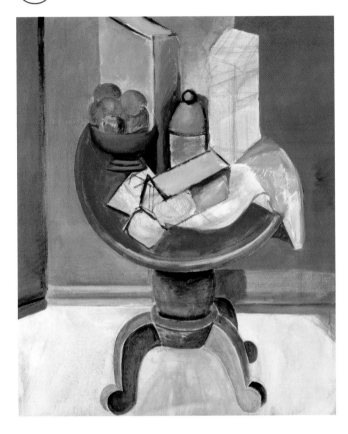

3. To compensate for the general darkness of the upper part, the floor has been left unpainted; this area, together with that of the cloth, is the main bright element in a chromatic composition dominated by chestnut brown colors.

A schematic approach is always the imagination's ally. It implies distancing from literal reality to give way to free pictorial interpretation of the subject.

4

4. The two boxes (a cereal box and a milk carton) have been treated very differently. While one of them is left barely painted, enhanced with very dry brushstrokes that expose the texture of the canvas, the other is constructed by accumulating heavy, thick paste to establish a clear pictorial contrast against the surrounding objects.

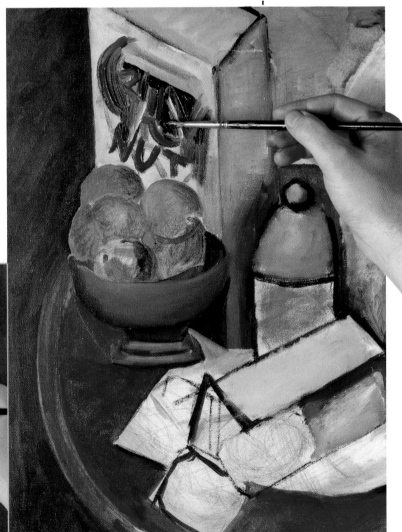

5

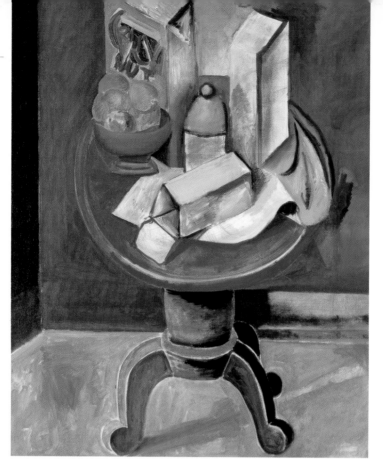

5. All the colors have been clearly defined. The floor has been darkened to avoid too strong of a contrast with the rest of the painting. The shadows have been reinforced and the objects modeled. All the surfaces have been reduced to a common color denominator: a chestnut gray with a few color details provided by the fruits and the bright chestnut tone of the table.

A

B

C

THE ARTIST CONCLUDES

The floor has been treated with a very diluted color glaze that enhances the texture of the brush marks against which the shadows projected by the table's legs stand out very convincingly (A). The chestnut color of the table is a counterpoint in a composition dominated by the grisaille in chiaroscuro. This was the initial foundation of the color scheme, and most of the other colors form part of it, even when they might have been modified by many gray nuances (B). The fruit is the other focus of color brilliancy, which counteracts and justifies the abundance of cool tones (C).

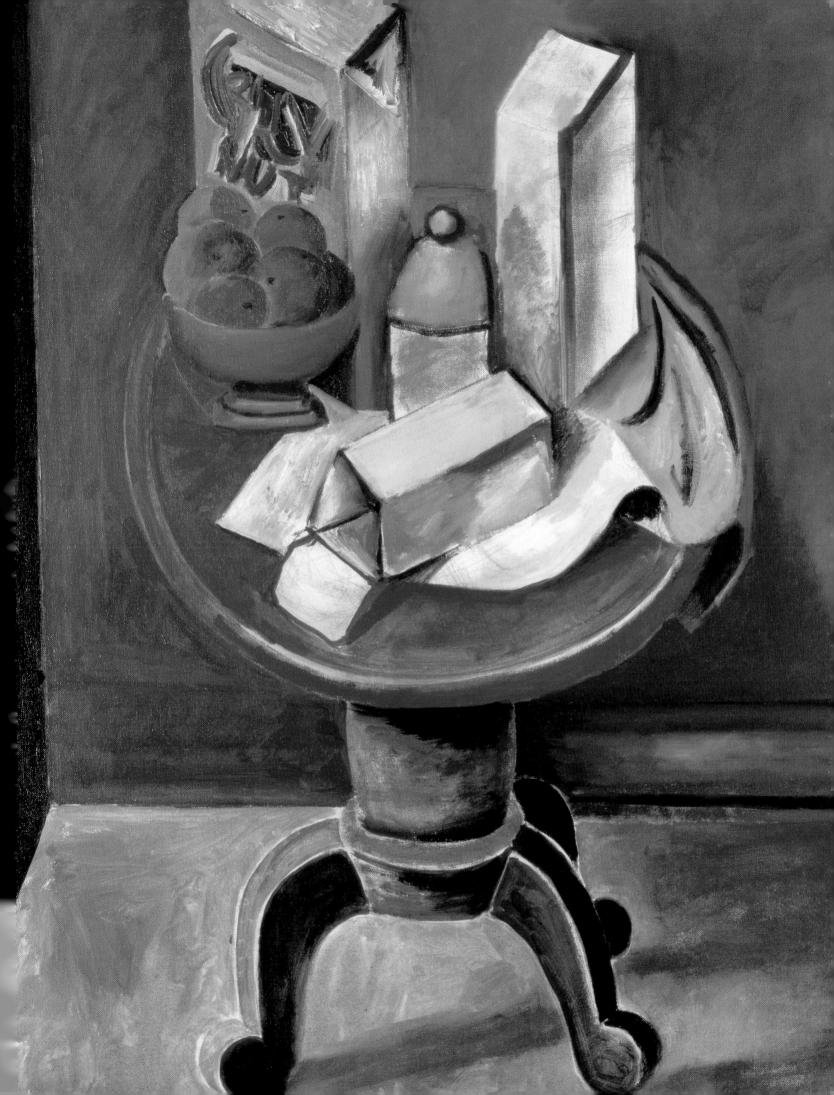

An Urban Landscape

The last exercise in this book consists of an urban twilight on the banks of a river. Even though this is an urban landscape, the vastness of the sky could classify this as a landscape in its own right. The richness of bright tones and the abundance of a variety of aspects in this scene inspire an interpretation rich in details. This is why the artist, David Sanmiguel, develops this painting in a way that is much lighter and more detailed than what this time of day would suggest.

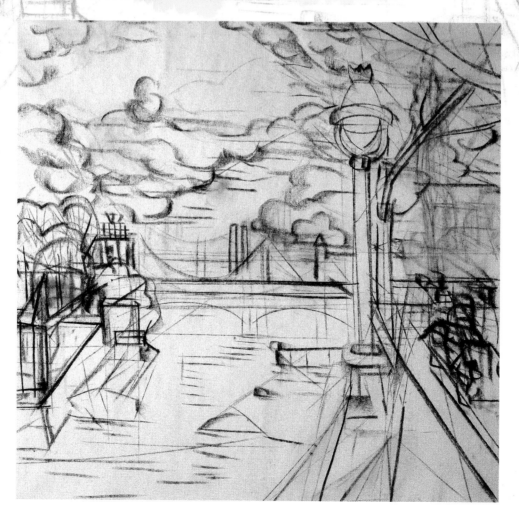

1

1. This drawing lays out clearer contours and outlines in a subject that does not have many due to the darkness of the time of day. This tells us that the interpretation is going to be quite free and focused on a panoramic view. The drawing develops many aspects that in reality are only suggested (clouds, buildings, trees, and so forth). The drawing has been made with charcoal and sealed with a fixative spray.

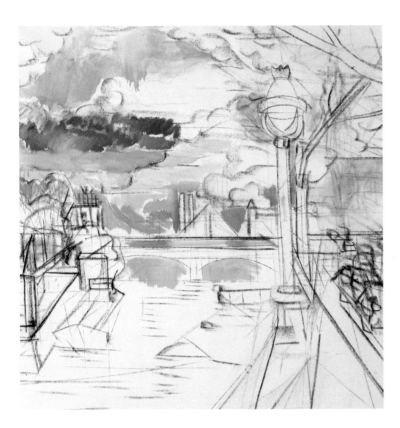

2

The charcoal drawing does not enclose the forms completely; it leaves them "open," unfinished. This is why the colors can be applied more freely without the restrictions of a rigid profile.

2. We begin painting at the center of the composition where the twilight is glowing. This first approach is meticulous, and small areas of color are established under the constant guidance of the charcoal drawing. Here, the warm colors are dominant: ochre and yellow, which will soon be enhanced by the light mauve and violets of the clouds.

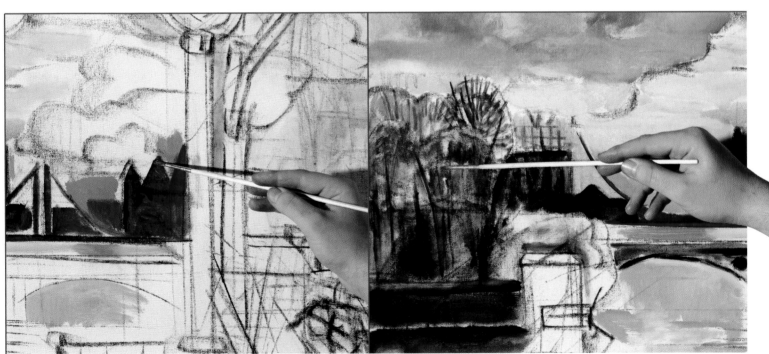

3

3. The buildings and the trees that stand tall in the horizon are painted with a chestnut color, avoiding gray and black tones. The idea is to safeguard the chromatic richness of this theme as much as possible. All these forms are silhouetted without introducing any details. The contrast is very graphic since there are a variety of dark shapes that all stand out against the light background.

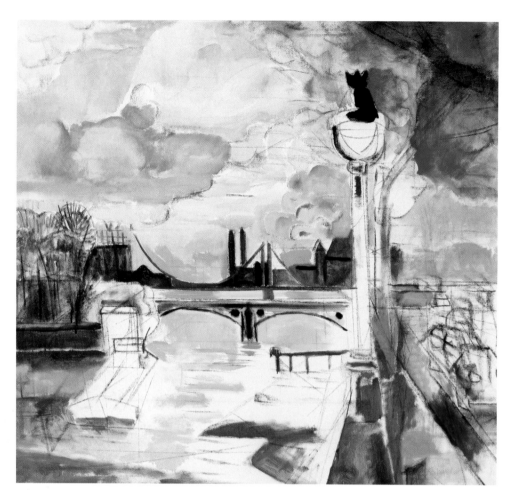

4

4. The painting proceeds by sections. Large areas of the river are still unpainted, waiting for the adjacent parts to be defined. The atmosphere is a pictorial element that has acquired more presence through the work done on the sky; a very light area and a very dark one made up of blues (ultramarine and cobalt) and violets (the former colors mixed with carmine).

5

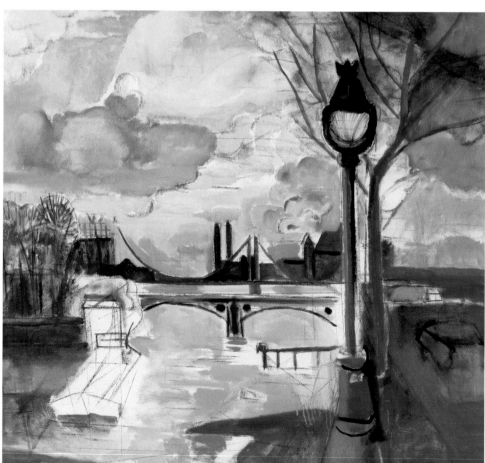

5. The foreground is painted with a neutral palette composed of ochre and raw umber. This color does have a twilight undertone and provides very convincing color nuances to the river. On the right side of the composition, urban elements begin to emerge making this motif recognizable. They also provide a sense of scale and spatial depth.

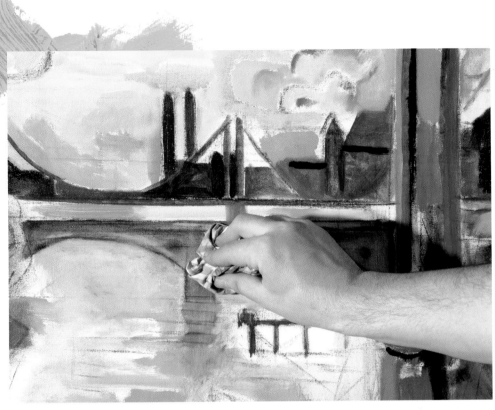

This boat has been executed in the Impressionist style. It emphasizes broad effects over particular details, which are almost totally absent in favor of freely distributed areas of contrast.

6

6. The most visible bridge in the composition (there is another one near the horizon) ruins the feeling of depth: It is too large. However, given that the painting is still wet, it can be removed with a rag. The traces of color cannot be eliminated, but they are easy to paint over. You must always be ready to make such corrections as the freedom to change your mind always outweighs strict adherence to the demands of the subject.

7. The river has been painted completely in the same green ochre color from the shadows, lightening it with white and a few touches of yellow. The foreground is finished (with very warm colors to emphasize spatial closeness), and the sky is very richly painted.

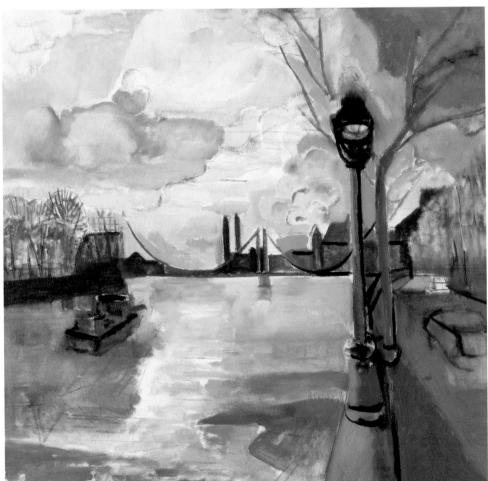

7

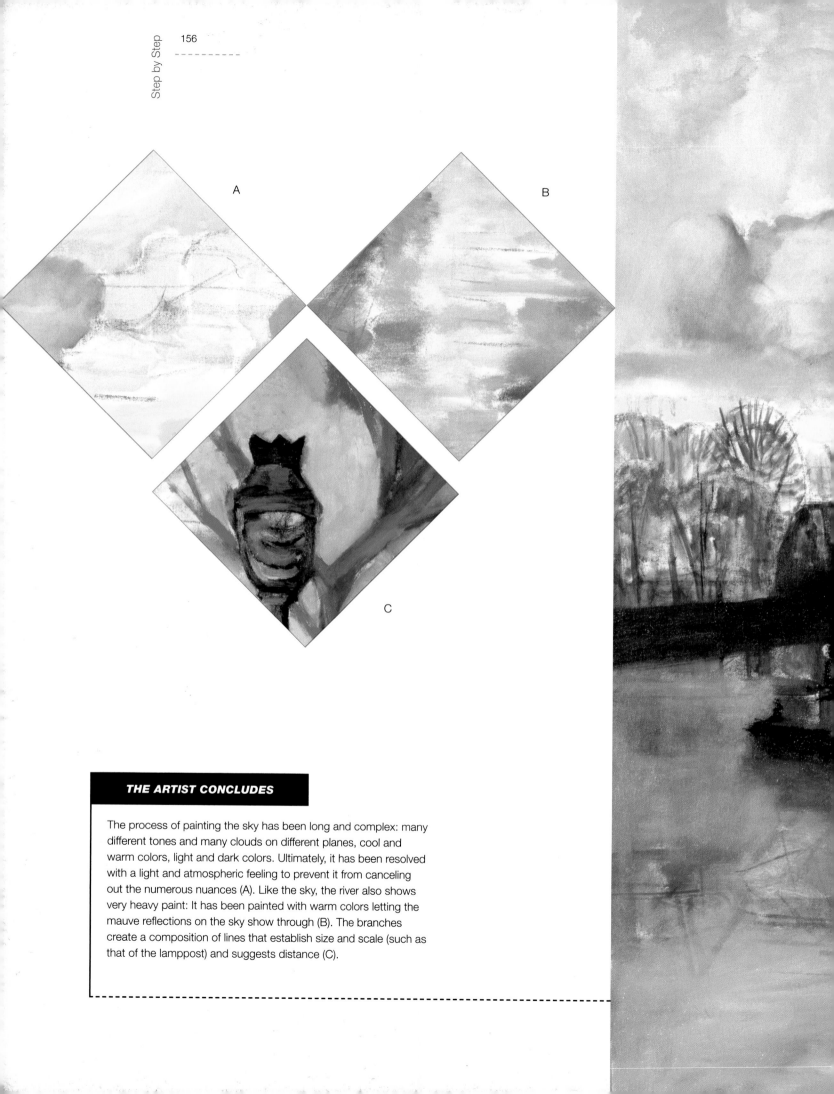

A

B

C

THE ARTIST CONCLUDES

The process of painting the sky has been long and complex: many different tones and many clouds on different planes, cool and warm colors, light and dark colors. Ultimately, it has been resolved with a light and atmospheric feeling to prevent it from canceling out the numerous nuances (A). Like the sky, the river also shows very heavy paint: It has been painted with warm colors letting the mauve reflections on the sky show through (B). The branches create a composition of lines that establish size and scale (such as that of the lamppost) and suggests distance (C).

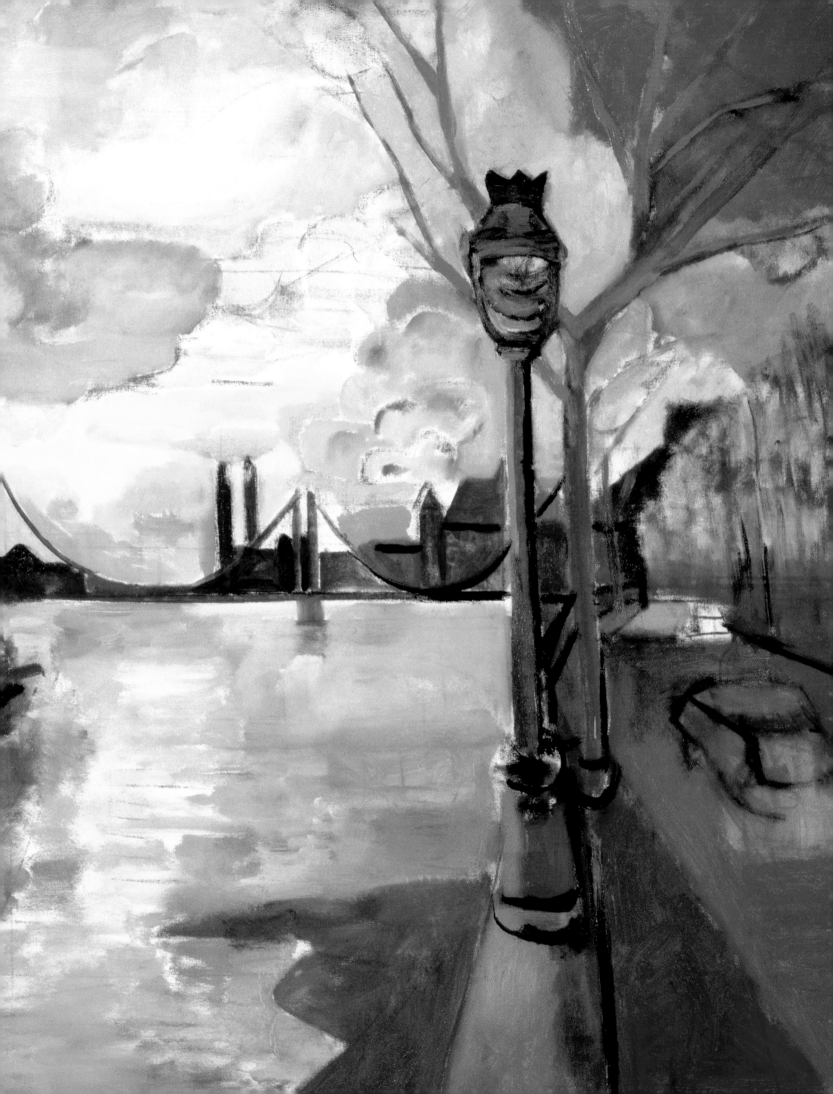

A

Abstract painting, 108–109, 112–113
 arrangement of, 37
Artist's colors, 22–37

B

Background, 95
 color, 125, 126, 148
 pictorial treatment of, 122
 surfaces in, 143
Black, 15, 25, 37, 70, 128–131
Blending color, 68–69, 134
Blue, 14, 15, 28–29, 37, 86, 132, 133, 138
 as cool color, 86
 pigments of, 28–29
Boxes, for oil paints, 21
Broken colors, 89
Brown, 15, 147
Brushes, 40–41
 assortments of, 40
 care and cleaning of, 41
 hog bristle brushes, 41
Brushstroke
 covering background, 84
 as drawing and color, 82
 of saturated color, 109
 size and direction of, 72
 strength of, 72
Burnt sienna, 77, 118, 124, 148

C

Carmine, 16, 17, 27, 126
Cézanne, Paul, 110
Chiaroscuro, 70, 146, 105, 146–147, 150
 interpretation of still life, 146–151
Chiaroscuro landscapes, 75
Chromium oxide cobalt, 14

Cobalt blue, 28, 29
Codes, on labels of oil paints, 15
Color(s)
 light and, 64
 in human figure, 136–139
 order of, 36
 paint guided by, 103
Color charts, 14–15
Color harmony
 cool colors, 9, 31, 86, 97, 106, 125, 142–143
 warm colors, 84
Colorist approach, to still life, 140–151
Colors and blends, 22–37
 see also individual colors
 broken colors, 89
 earth tones, 32–33
 flat colors, 89
Colors, paints, and pigments, 14
Commercial assortments of paints, 20–21
Components of paints, 10–21
Composition with warm colors, 85
Consistency of paint, 44–45
Contrast, 147
Cool colors, 29, 31, 86, 86–87, 97, 106, 125, 142–143
 harmony with, 86–87

D

Darkening of oil paint, 13
Dark to light, 70–71
Digital reproduction, 141
Dilutions of color, 47, 54, 56–57
Direct impasto, 62–63
Drawing
 on canvas, 147
 countours and outlines in, 152
 from drawing to color, 54–55
 preliminary, 142
 schematic, 143
 as starting point for painting, 141

Dryers, 46–47
Drying
 oil for, 12
 speed, 13, 16
Durability of paint, 15

E
Earth tones, 17, 32–33

F
Fabric, 42–43, 44, 45
"Fabric" of color, 82
Fabricating a wax medium, 48
Fernández, Hector, 94, 95, 96, 98
Figure in an interior, 96
Figure, portrait, still life, and
 landscape, 92
Flat colors, 89
Flesh tones, realistic
 interpretation of, 100–101
Flowers, pictorial rending of, 2, 6,
 27, 35, 43, 44, 55, 62–63,
 80–81, 82–83, 88–89,
 120–123
Foreground, painting of, 154
Fruit, pictorial rendering of, ii–iii,
 17, 25, 49, 56–57, 58–59,
 65, 71, 72–73, 146–151,
 102–103, 132–135,
 146–151

G
Gispert, Joan, 49, 102, 103, 105
Glaze, 150

Gray, 34–35, 88, 128–131, 137,
 138, 147, 150
 as neutral color, 88–89
 pigments of, 34–35
Green, 14, 15, 25, 30–31, 35, 55,
 72, 89, 99, 126, 138
 as cool color, 86
 pigments of, 30–31
Grisaille, 60, 61
Guiding paint by color, 103
Guston, Phillip, 90
Gutiérrez, Alberto, 66, 96, 99,
 101

H
Harmony, with color, 84–89
Heavy color, 58–59
Horses, pictorial rendering of, 33,
 116–119
Hot pressing versus cold
 pressing, 12
Human figure, 95–101, 136–139

I
Impasto, 58
 and blending color, 69
 direct impasto, 62–63
 with local color, 72
 with oil, 133
Interpretations of a still life
 a colorist approach, 140–145
 chiaroscuro, 146–151

J
Labels on oil paints, 15, 16
Landscapes
 combination with seascape,
 124
 natural, 104
 near the sea, 124–125

themes of, 105
 urban, 104
Light, 78, 104
 and color, 64-89
 from color, 80–81
 natural light, 104
Lightening of oils, 13
Lightfastness, 16
Light to heavy color, 60–61
Line(s)
 emphasis of, 108
 in human figure, 136–139
Linseed oil, 12, 13, 18

M
Manufacturing of oil paints,
 18–19
Mas, Yvan, 29, 35, 61, 75, 81, 92,
 112, 120
Materials of the oil painter, 8–49
Matisse, Henri, 8
Mediums, 46–47, 48
Modeling and impasto with local
 color, 72–73
Modeling and light, 73
Modeling the volumes, 68–69
Modeling without blending
 brushstrokes, 76–77
Monet, Claude, 64
Münter, Gabriele, 29, 86–87, 89

N
Nature, 104–105
Neutral colors, 35, 88–89
Nudes, pictorial rendering of, 45,
 91, 98–101

O
Ochres, 25, 126–127, 129
Oil paints, making, 18–19

Index

Oils, used in oil painting, 12–13
 description of, 12
 diluted, 54
 linseed oil, 12, 13
 poppy oil, 12
 walnut oil, 12
Olivé, Esther, 73, 140
Opacity, 16, 56–57, 61
Orange, 15, 16, 24, 142
 pigments of 24
Order of the colors, 36–37

P
Painting knives
 types of, 41
 working with, 132–135
Painting, technical process of,
 50–63
Palette, 36–37, 58
Palette knives, 41
Pascual, Alex, 10, 106, 108
Paste, 11
Pencil drawing, 116
Perceptions of colors, 14
Permanence of oil paint, 16
Petroleum distillates, 46
Phthalo copper chloride, 14
Pigments, 12, 14–15, 22–37
 meaning of 15
Pink, 17
Preservation of paint, 19
Primary colors, 23
Process of creating a painting,
 52–61

Properties of oil paints, 16–17
Puig, Esther Olivé de, 25

R
Red, 15, 16, 17, 25, 26–27, 29,
 35, 37, 58, 72, 126, 128,
 133, 142
 pigments of, 26–27
Renoir, Pierre-Auguste, 50
Riverscape, urban, 112–113
Rosins, 48–49

S
Sanchis, Óscar, 22, 31, 36, 38,
 63, 71, 72, 73, 78, 104, 105,
 116, 124
Sanmiguel, David, 33, 35, 44, 52,
 72, 77, 85, 136, 146, 153
Seascape, 105
 combination with landscape,
 124–125
Solvents, 46–47
Space, 74
Step by step process of oil
 painting, 110–157
Sticks, 20
Still lifes
 in color, 102
 details of, 144
 interpretations of, 140–151
 with a limited color range,
 128–129

Supports for paint, 42–44
Surfaces, rendering, 143

T
Texture of fabric, 42–43
Themes, for oil paintings, 90–109
 universal, 94–95
 urban, 106
Tulips, 120–124
Transparency, 16, 56–57
Tubes of oil colors, 16, 21
Turpentine, 46, 48, 54
Turquoise, 16
Two riders on horseback, 116

U
Ultramarine, 28, 29
Universal theme, 94–95
Urban landscape, 152
Urban riverscape, 112
Urban scene, 104
Urban theme, 106–107

V
Values, 74
Varnish, 47
Vases, depiction of, 120–124
Violet, 15

W
Warm colors, 84–85, 97, 106,
 125, 126, 129, 155
Wax medium, 48–49
White, 15, 37, 70, 109, 128–131,
 133, 138

Y
Yellow, 15, 17, 24–25, 35, 37, 58,
 72, 82, 126, 133, 142, 155
 mixtures with, 25
 pigments of, 24–25
Yellowing of oil paint, 13